IMAGES
of America

CAMP MATHER

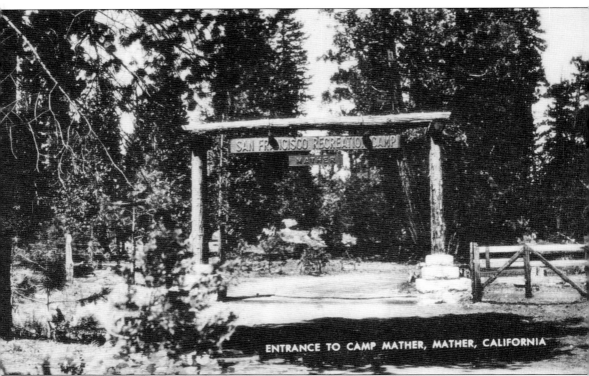

ENTRANCE TO CAMP MATHER, MATHER, CALIFORNIA

This postcard from the 1940s depicts the entrance to San Francisco's Recreation Camp, now called Camp Mather. For travelers, the appearance of the sign is a welcome indication that the long journey from the city is about to be over and a restful and relaxing time is about to begin. Now folks can fish, swim, hike, ride, explore, and inspect to their heart's content knowing that a well-prepared meal awaits them at the end of each busy day. (Courtesy of the author's collection.)

ON THE COVER: The year is 1927, and the city's municipal camp, Margaret Maryland, is in its third year of operation. A shallow lake, fed by its own spring, was created from a gravel extraction site located near the sawmill used during the construction of the Hetch Hetchy dam. It quickly became a popular place for camp guests to spend the day. During the ensuing decades, the lake will be dredged and deepened, the dock and bathhouses will be changed many times, and diving boards and towers will be altered and removed. Birch Lake will, nevertheless, remain the focus for social life at the camp. (Photograph by Horace B. Chaffee; courtesy of San Francisco Public Utilities Commission.)

IMAGES
of America

CAMP MATHER

Michael Buck

ARCADIA
PUBLISHING

Published by Arcadia Publishing
Charleston SC, Chicago IL, Portsmouth NH, San Francisco CA

Printed in the United States of America

Library of Congress Catalog Card Number: 2008920090

For all general information contact Arcadia Publishing at:
Telephone 843-853-2070
Fax 843-853-0044
E-mail sales@arcadiapublishing.com
For customer service and orders:
Toll-Free 1-888-313-2665

Visit us on the Internet at www.arcadiapublishing.com

*This book is dedicated to the memory of Margaret Mary Morgan,
an unsung hero in the annals of San Francisco.
Her vision of a municipal camp in the Sierra became a reality
during her first term as a supervisor. As a result of her efforts,
many generations of San Franciscans have been able
to enjoy a magical time at a very special place.
And to my wife, Marcia, who first introduced our family to Camp
Mather many years ago and whose support, encouragement, and fine
editing skills have made this book possible.*

CONTENTS

ACKNOWLEDGMENTS

The genesis for this book was a tour of the Camp Mather kitchen I took several years ago. Chef Mike Cunnane invites guests to learn what goes on behind the scenes in the dining hall. It was far more interesting than I could have imagined, as Mike interspersed his comments with historical lore. The book that follows is a continuation of that stroll through the kitchen.

Beverly Hennessy of the San Francisco Public Utilities Commission (PUC) deserves a special thanks for giving me access to that agency's superlative collection of photographic images. Katherine Du Tiel, the photograph archivist of the PUC, was a tremendous help, as were Claudia Day at Moccasin and Diane Parker in San Francisco, who assembled precious historical records.

The staff of the San Francisco History Center at the San Francisco Public Library was tremendous. Christina Morettia, Frank Vaughn, Tom Carey, Tim Wilson, and Jason Baxter guided me to the right resources, gathered information, and prepared digital images. It was a pleasure to work with such a competent and knowledgeable group of professionals. Thanks to Lorna Kirwan of the Bancroft Library and Miranda Hambro of the Environmental Design Archives of the University of California, Berkley for their help with images.

Thanks to Joan Ruddy of the Sonora Public Library and Lisa Smithson of the Tuolumne County Museum; Priscilla M. Refold Guzman of the Groveland Ranger District, Stanislaus National Forest; Kathy Strain of the Forest Service Heritage Program; Linda Eade of the National Park Service in Yosemite; and author Sharon Giacomazzi. Many thanks to Lynn Ludlow for great discussions about the camp and for research tips; Lou Ravano for access to the George Albrecht photograph collection; Tony Patch for history learned over lunch at the Double Play; Tom McAteer for the "Shang" photographs; Dan Braun and Lee Zimmerman of the Evergreen Lodge; Robin Scher of the Friends of Camp Mather; Claudia Reinhart and Ellen McAllister for the photographs; and Shirley Barisone for her support, photographs, and reminiscences. Special thanks to Jeff Garrison for the use of his family's photograph collection. Appreciation is also due to Terence and Patrick Hallinan for family photographs and wonderful stories about their summers at Camp Mather.

Strong recognition is due to Neil Fahy and Richard Schadt. Each has assembled a major collection of documents, photographs, ephemera, historical records, and knowledge that they kindly shared with me. There would be no book without their kindness. One cannot find a better collaborator in the process than John Poultney at Arcadia Publishing. He guided me each step of the way and prodded me when a deadline was up. Thanks!

Images without attribution are from the author's personal collection.

INTRODUCTION

The story of Camp Mather is intertwined with the construction of the O'Shaughnessy Dam in the Hetch Hetchy Valley of Yosemite National Park. The requirements of the Raker Act, the construction of a work camp at Hog Ranch, and the vision of San Francisco's first elected woman supervisor eventually resulted in the opening of San Francisco's municipal camp in 1924.

Still a controversial subject for almost 100 years, the decision in 1916 to allow construction of a dam in a national park had been previously debated through three presidential administrations and sharply pitted early environmentalists against each other. Development of the valley was a foregone conclusion for both sides. The central question was what was the best public use of the valley.

The "preservationists," led by John Muir, William Colby, members of the Sierra Club, and other nascent environmental organizations of the time, strongly believed that the valley should be maintained and developed for public recreational uses. The "conservationists," including among their ranks Gifford Pinchot (first chief of the U.S. Forest Service) and other progressives, felt that San Francisco's desire to have a safe and reliable water supply met the "greatest good for the greatest number" test.

The 1913 Raker Act authorized the construction of the dam and its attendant power system, but prohibited sale of the generated electricity and legally obligated San Francisco to remove any construction scars from the valley. Lands owned by the city would return to the national park upon completion of the dam. New trails, all-weather roads, and recreational facilities would be developed and paid for by the city.

The Hetch Hetchy Railroad was constructed to bring equipment and supplies to the dam site. Hog Ranch, an early homestead about six miles from the valley, was an ideal spot for a construction camp, and the city built a second sawmill there to prepare lumber for the project. An early resort with wooden cabins and a dining facility had been developed at the ranch by the Yosemite National Park Company. It was later purchased by the city to form the nucleus of a worker camp and eventually became the core of what is now Camp Mather.

Because the construction of the dam was a major engineering and financial undertaking, city officials and the public were naturally curious about the project. Weekend excursions were organized to bring visitors from the city or from Yosemite to stop at what was now known as Mather Station and take a tour of the dam. Likewise, city officials frequently visited the project to monitor its progress. On the way to the dedication ceremony in 1924, Margaret Mary Morgan, a city supervisor, observed the City of Oakland's camp along the Middle Fork of the Tuolumne River, and upon arriving at Mather Station, she conceived the idea of a locating a San Francisco municipal camp in the area. With the support of Michael O'Shaughnessy, the chief engineer of the Hetch Hetchy Project, she was able to see her "pet project" become a reality, and in honor of her efforts, the camp was named Margaret Maryland.

At the time Mather Station was being developed, other activities were occurring in the area. The California Peach and Fig Growers Railroad was milling timber a few miles down the road

and using the city's Hetch Hetchy Railroad to transport finished goods to its packing sheds in the San Joaquin Valley. The Carl Inn was a booming resort located on the South Fork of the Tuolumne River. Adjacent to Mather Station, the Evergreen Lodge would evolve from its humble beginnings as an after-hours gathering spot for work crews, to a popular resort in its own right. The Cliff House, located down by Rainbow Pools, would become a mandatory stop for buses and private automobiles coming from San Francisco to the camp.

Swimming at Birch Lake, riding horses rented from Joe Barnes's corral, enjoying wonderful food at the dining hall, hiking to Inspiration Point, and participating in any number of organized camp activities have long been the source of many stories and warm memories. Generations of San Francisco families have come to Camp Mather as children and then later brought their own kids.

For one week out of the year, 400 or so individuals come together to form a village that is united in its appreciation for the special place that is Camp Mather. During the Depression years, in the postwar boom, and now into the 21st century, the lure of the camp has remained steady. Those visitors still living who were fortunate enough to attend camp in late 1940s and early 1950s vividly recall their experiences and memories of their friends long departed. For many of them, experiences at Mather provided defining moments in their lives. Time has not dimmed those memories.

Whether you pronounce it Mather as in "gather" or Mather as in "bather," folks know what you are talking about. What is important is that you annually meet with dear friends in that special Sierra spot and enjoy yet another summer with a singular San Francisco experience.

One

HETCH HETCHY VALLEY

The majesty of the Hetch Hetchy Valley was once largely unknown except to the Miwok and Paiute Indian tribes and pioneer homesteaders. Livestock operators were quick to take advantage of the lush vegetation and grazed their sheep and cattle in the wide meadows. Early backcountry folks, like John Muir, were well aware of the valley's resources, and others discovered its incomparable scenery through camping expeditions organized by the Sierra Club. When San Francisco first sought approval to dam the valley in order to create its municipal water supply, few other people had ever visited the valley or even knew of its existence. It was remote and difficult to reach; thus, its constituency was limited when the political battle over the city's proposal erupted across the nation. Painters, photographers, poets, and writers were able to successfully capture the beauty of the setting; however, those images failed to reach a larger audience. Opponents of the project underestimated the city's resolve to build the dam (even though reasonable alternatives existed), and the underfunded, understaffed groups were simply outmuscled by the city's financial resources and political connections. The Raker Act of 1916 permitted the city to move ahead with its water project, and the first waters of the Tuolumne River began to back up behind the O'Shaughnessy Dam in 1923 when it was acclaimed as the largest single structure on the West Coast. Other conditions of the act addressed issues of electrical power distribution and recreational amenities. Although the valley remains inundated, it is fortunate that the early works of Alfred Bierstadt, Joseph N. Le Conte, Harriet Monroe, and John Muir survive to remind everyone of what is no longer. The lessons learned from the battle over Hetch Hetchy were not lost on these early activists, and during the decades that followed, environmental groups have been successful in preserving other national parks from inappropriate development.

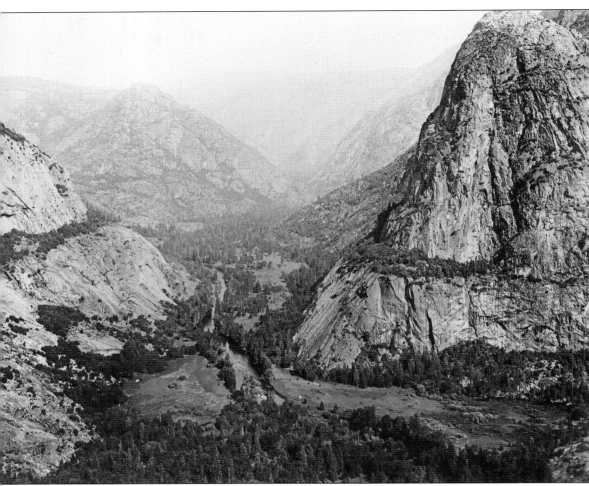

Those who made the arduous journey to the remote Hetch Hetchy Valley were well rewarded by spectacular views like the one depicted in this photograph, taken in 1913. It shows the upper Hetch Hetchy Valley looking southeast from a point near the top of Wapama Falls, divided between the Tuolumne River and Rancheria Creek, with LeConte Point in the center and Kolana Rock on the right. (Courtesy of San Francisco Public Utilities Commission [PUC].)

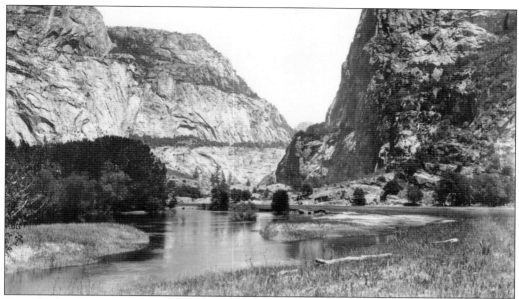

From the headwaters on Mount Lyell in Yosemite National Park, the Tuolumne River responded to the topography of the area to create waterfalls, deep pools, and the Grand Canyon of the Tuolumne as it leisurely made its way to the Pacific Ocean. In this picture from the 1900s, the river winds sinuously through the Hetch Hetchy Valley before it passes through a narrow gorge and falls into the Poopenaut Valley. (Photograph by Joseph N. Le Conte; courtesy of Bancroft Library.)

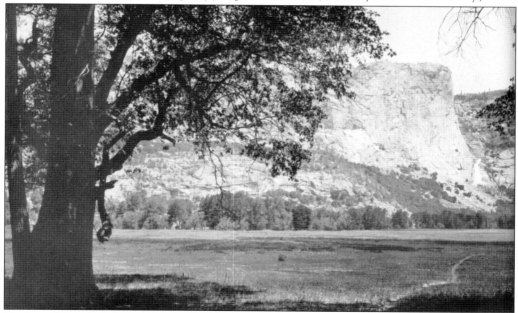

To the right in the picture, an inviting trail leads the intrepid hiker across the valley floor toward Wapama Falls in the distance. Black oak acorns and seeds from grasses supplemented the food obtained by hunting and fishing to give the Central Miwoks a varied diet. Trade with the Paiutes provided supplies of salt and obsidian for knives and arrows. (Photograph by Joseph N. Le Conte; courtesy of Sierra Club.)

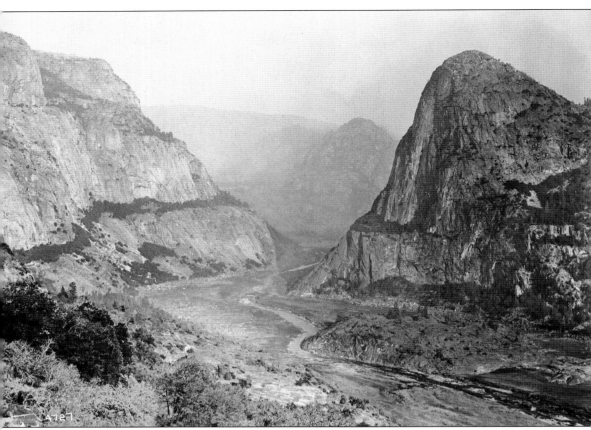

This 1917 view shows the Hetch Hetchy Valley looking upstream from the road on the north side of the valley. In preparation for the construction of the dam, the valley was stripped of its vegetation, the lumber harvested, and a worker camp established on the meadow floor where waist high ferns and grasses once flourished. (Photograph by Horace B. Chaffee; courtesy San Francisco PUC.)

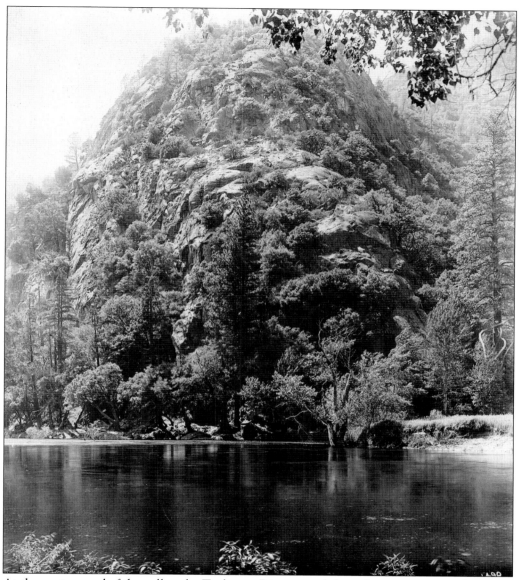

At the western end of the valley, the Tuolumne River passed through a narrow gorge that, from an early-20th-century engineering standpoint, made it an ideal dam site. The northern wing of the dam was attached to the granite wall of the canyon, and the foundation of the dam was 118 feet below the original streambed. (Courtesy of San Francisco History Center, San Francisco Public Library.)

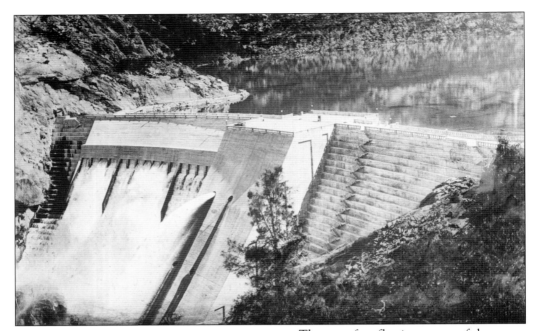

The once free-flowing waters of the Tuolumne River are now impounded behind the completed O'Shaughnessy Dam. At the time of its dedication on July 7, 1923, it was the second highest dam in the United States. By October 1938, the dam will have been raised an additional 85 feet to its present configuration and a tunnel bored through the granite on the north side of the dam. A new road was also constructed that provided hikers with access to the Wapama, Tueeulala, and Rancheria waterfalls. (Courtesy of San Francisco Public Library.)

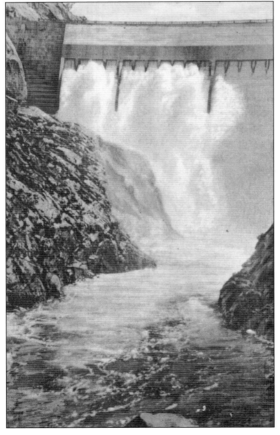

A postcard from the late 1920s shows water racing over the spillway of the O'Shaughnessy Dam as it begins its 149-mile journey to the city's storage facilities in the coastal foothills of San Mateo County. Ironically, Michael O'Shaughnessy, the dam's namesake, would die shortly before the first waters of the Tuolumne flowed through the Pulgas Water Temple and then into the Crystal Springs reservoir.

Two

HOG RANCH

Early activities at Hog Ranch were generally limited to use of the meadows and valleys to raise sheep and cattle. It is unclear who built the cabin in 1856, although it is accepted that D. G. Smith had laid claims to the surrounding area for grazing purposes. Cavalry were posted in the area to keep cattle and sheep out of Yosemite National Park. The use of the term Hog Ranch can be confusing. The name originally applied to the homestead and cabin known locally as Hog Ranch. It was later used to identify the 300-plus-acre tract of land acquired by San Francisco for use as a railhead and ancillary facilities connected with the construction of the O'Shaughnessy Dam.

At the beginning of the 20th century, change was coming to the area. Agricultural and urban interests viewed the Sierra rivers as resources to be tapped to meet the growing demand for reliable supplies of water. Public and private survey crews frequently visited the area, and Hog Ranch, located along the major routes to the Hetch Hetchy Valley, became the locus of much activity. Hog Ranch was the jumping off point for all visitors and supplies for the damn construction in Hetch Hetchy Valley. Everything was packed in on horseback, and it took a half a day over steep and rocky horse trails to reach the construction camp at the dam site. The topography of Hog Ranch made it an ideal spot to stockpile equipment and supplies. When the Hetch Hetchy Railroad was later constructed, the flat areas of the ranch were found to be ideal sites to establish its railhead. Other nearby locations were well suited for the sawmill and ancillary facilities the city would build after timber supplies near the dam site were exhausted. Briefly called Portulaca, a misguided attempt to tart up the place, the name would be permanently changed to Mather in 1919 by Michael O'Shaughnessy, the chief engineer of the Hetch Hetchy project.

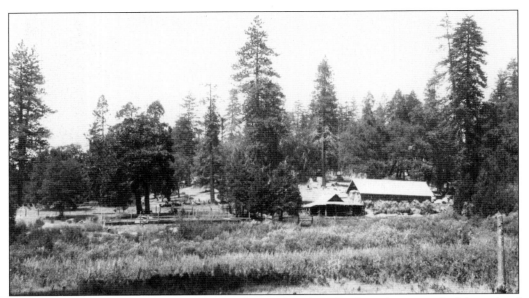

Shown in this 1916 picture, the building with its a sloped roof and porch is typical of the style of cabin found throughout the area. There is a disagreement among contemporary historians as to whether the structure in this photograph is the Hog Ranch cabin that was built in 1856. It does, however, remain standing in a remote location at Camp Mather. (Photograph by Ernie Beck; courtesy of Tuolumne County Museum.)

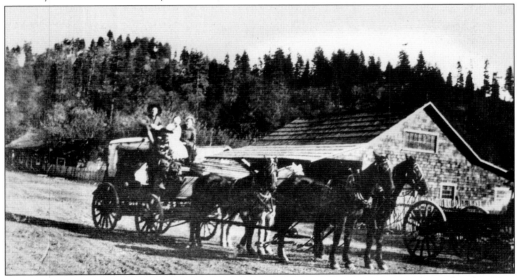

The ranch was like a lovely valley—wide and grassy, broken with clumps of oaks and cedar. Hog Ranch was a not a busy place; however, the area was a prime spot for visitors passing though on their way to the Hetch Hetchy Valley. It became a stage stop in 1903. Uncomfortable for passengers who had to endure brutal, bone-jarring dirt roads; progress-halting mud; and choking dust; stages were nonetheless an important early transportation link. Here Charlie Baird's stage makes a stop at the ranch in 1917. Prior to the construction of the Hetch Hetchy Railroad, Baird provided daily stagecoach service from Groveland to Hetch Hetchy, a two-day trip that required an overnight stay at Jones Station. (Courtesy of Tuolumne County Museum.)

An early survey team pauses before the cabin at Hog Ranch. Around 1910, a name change was suggested for Hog Ranch. City engineer Marsden Manson proposed "Portulaca" after a plant found in the Yosemite region (but not at Hog Ranch). The name never took, and it would remain Hog Ranch until 1919 when it became Mather Station. (Courtesy of Neil Fahy.)

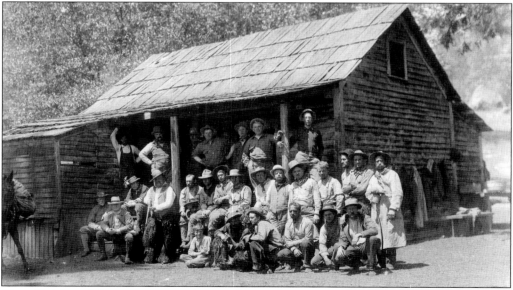

City officials and the press were anxious to observe the progress of the dam's construction in the valley. After enduring a two-day journey from San Francisco by train and stage to Hog Ranch, they then faced a nine-mile trek by horseback on a trail that wound over bare granite rocks, detoured around huge boulders, and followed steep descents before reaching the valley floor. Here the group poses for the obligatory photograph in front of the Hog Ranch cabin. (Courtesy of Neil Fahy.)

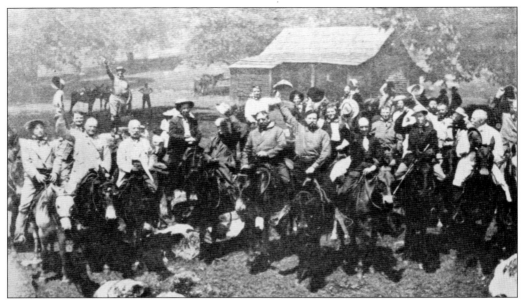

In 1908, fourteen of the 19 members of the board of supervisors, along with the press and other city officials, were joined by private citizens willing to pay their own way on an official tour of the valley. They memorialized their Hetch Hetchy trip by inscribing the date of their visit over the door of "Portulaca" cabin. The celebratory mood of the group is most likely due to anticipation of the trip to the valley rather than any excitement generated by their return. (Courtesy of Richard Schadt.)

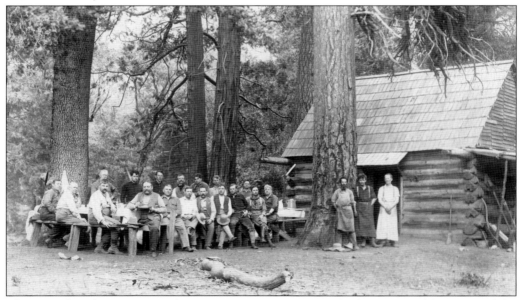

This 1910 shot shows a group of San Francisco supervisors and other city notables at one of the cabins that could be found in the valley prior to its inundation. In spite of the difficulty in getting supplies to the site, resourceful camp cooks were noted for their ability to prepare wonderful meals that most likely included fresh-caught trout from the nearby Tuolumne River. (Courtesy of Neil Fahy.)

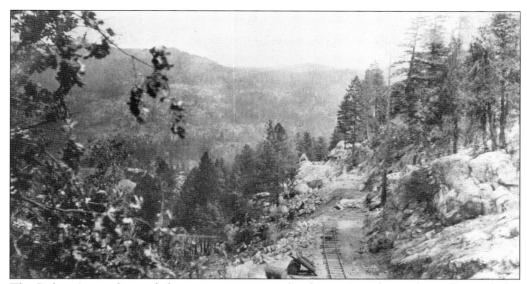

The Raker Act authorized the city to construct the dam in Hetch Hetchy Valley and also obligated San Francisco to build miles of trails and roads in Yosemite National Park. In 1914, the city constructed a road from Hog Ranch to the valley. Initially used by wagons to transport material to the dam site, it would later serve as the track bed for the Hetch Hetchy Railroad. This 1914 view looks toward Hetch Hetchy about two miles from Hog Ranch. (Courtesy of San Francisco PUC.)

Crews working in the Sierra often faced formidable obstacles while building roads. Granite cliffs and massive boulders made for slow going, and explosives were used to remove the material. The aftermath of a recent big blast on the new road to Hetch Hetchy dwarfs a worker standing in the middle of a pile of rubble. (Courtesy of San Francisco PUC.)

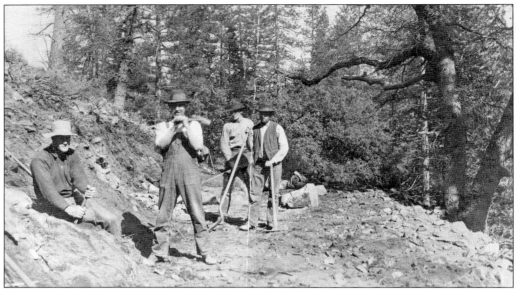

Until the Hetch Hetchy Railroad was completed in 1917, all supplies had to brought in by wagon. In the early days of construction, roads were built by work crews using tools and equipment not unlike those used in the 1860s to build the transcontinental railroad across the Sierra. This 1914 photograph depicts a group of men working on a wagon road to the valley. (Courtesy of San Francisco PUC.)

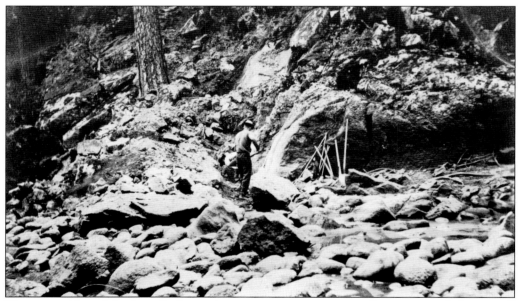

The steep sides of the heavily forested mountains, numerous small streams, and the overall inaccessibility of the area made road building a torturous process. The amount of debris to be cleared after each blast must, at times, have seemed overwhelming to the crews who were working in remote and difficult terrain. Here a single worker equipped with only a shovel begins work on the huge rock pile. (Courtesy of San Francisco PUC.)

Three

MATHER STATION

Work on the dam was well underway when two major personalities of the era, Stephen T. Mather and Michael O'Shaughnessy, clashed over the city's responsibilities to the national park as mandated by the Raker Act. O'Shaughnessy became increasingly proprietary with regard to the lands surrounding the reservoir and was leery of opening Hetch Hetchy to public access. Mather's early vision and direction became the guiding force of the National Park Service, and he was quite clear about the standards for new roads and the public's right to use the national parks. O'Shaughnessy was a commanding figure: he had excellent engineering credentials and, recognizing that his role would be critical to bringing the water project in and under budget, San Francisco mayor James Rolph Jr. insisted O'Shaughnessy report only to him. The nearly impassable mountains and associated engineering problems presented formidable obstacles. The plan to build a road from the valley to the dam site was abandoned because it would be too expensive and time consuming. Instead, a standard-gauge railway that was 68 miles long was constructed from Hetch Hetchy Junction (26 miles outside of Oakdale) to the rim of the Hetch Hetchy Valley. It was completed in 1917 at a cost of some $2 million and operated around the clock during dam construction using one rented locomotive and six of the city's locomotives. Activity around the dam site lured both city officials, anxious to monitor the progress of a multimillion-dollar project, and curious onlookers, who were able to visit the dam site during weekend excursion tours. Additionally, the availability of a rail line linked to the connections in the San Joaquin Valley made it possible for other companies to take advantage of the rich timber resources in the area. The California Peach and Fig Growers Railroad built a short-line system and sawmill. As a business venture, it was not long-lived and remains a curious footnote in the history of the area.

A graduate of Lowell High School and the University of California, Berkeley, Stephen Tyng Mather was the first director of the National Park Service. Work on the dam was well underway by the time he was appointed director in 1916; however, Mather insisted that the city leave no scars upon the land as a result of its construction activities in the mountains. He also correctly surmised that the city had no intention of complying with the conditions of the 1913 Raker Act. He was rebuffed by the city and heavily criticized by the press as he sought more definite commitments regarding the recreational facilities to be provided by the city. Mather never regarded the act of giving his name to the Hog Ranch railroad terminal as a compliment.

Michael Maurice O'Shaughnessy was a highly regarded, politically savvy engineer. Affectionately known as "The Chief" by those who worked under him, his somewhat abrasive style did not prevent him from assembling a brilliant team to complete a complex project. His decision to rename Hog Ranch to Mather Station was a feeble attempt to mollify Stephen Mather over the issue of roads and other Raker Act promises made by the city. (Courtesy of San Francisco PUC.)

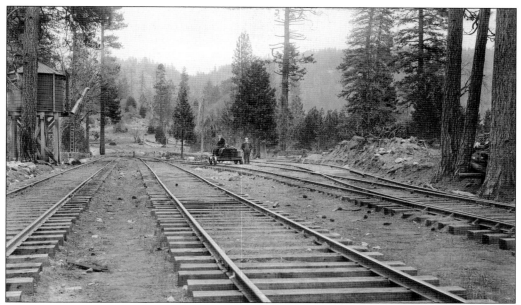

During construction of the dam, the level area and wide meadows of Hog Ranch made it an ideal location for the city's base of operations. Large amounts of material and equipment could be stockpiled and subsequently transported to the dam. The railroad was completed in 1917 at a cost of just under $2 million. Hog Ranch would soon be known as Mather Station. Other changes to the area included wooden cabins that replaced worker tents, the development of a short-line railroad, an influx of visitors to the site, and the establishment of a sawmill near now what is Birch Lake. (Courtesy of San Francisco PUC.)

The Mather site was a rich source of timber for the newly built sawmill. Eventually, over 21 million board feet (mbf) of yellow pine, sugar pine, red fir, and cedar would be harvested and milled. (Photograph by Horace B. Chaffee; courtesy of San Francisco PUC.)

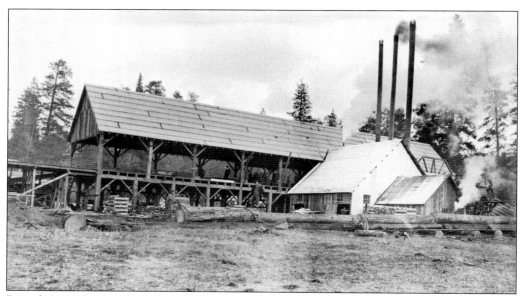

By early 1917, the city sawmill at Canyon Ranch had milled over eight million board feet of lumber from the city's own timber stands at Canyon Ranch and from trees felled in the Hetch Hetchy Valley. The lumber was used for railroad ties, construction camps, trestles, stations, and even cars. The mill was dismantled, brought to Mather Station, and then reassembled. Cutting at the mill averaged 25,000 to 30,000 feet per eight-hour shift. (Courtesy of San Francisco PUC.)

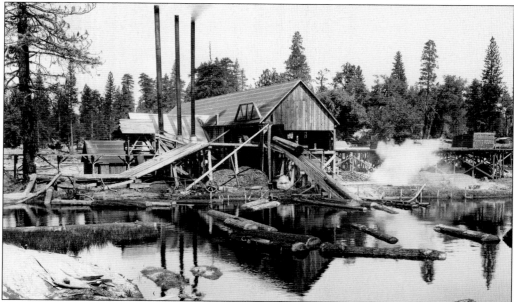

This photograph, taken in August 1921, shows a general view of the sawmill. Logs were stored in a second pond, Mirror Lake, which was shown on early maps of the area. It would take years for the area to recover from the sawmill's use. Today, with the present swimming pool occupying what was once the mill site, it is hard to believe that the Birch Lake area, surrounded by a lawn and beach, was once a thriving industrial site. (Photograph by Horace B. Chaffee; courtesy of San Francisco PUC.)

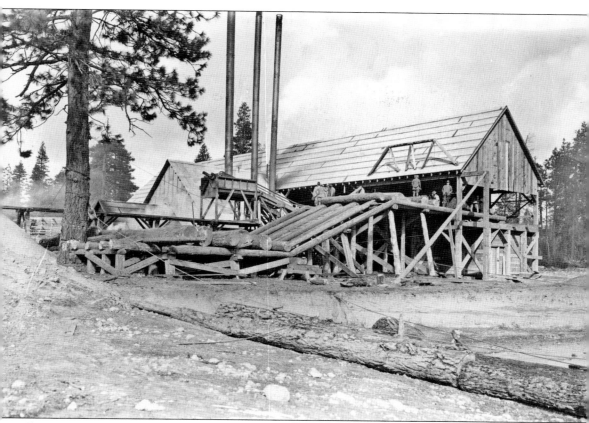

This 1919 picture of the sawmill shows logs that have been cut to uniform size awaiting further milling. While the air must have been heavy with the smell of pitch from freshly cut lumber, the noise of the huge saws was deafening and resonated constantly during the day while the mill was operating. (Photograph by Horace B. Chafee; courtesy of San Francisco PUC.)

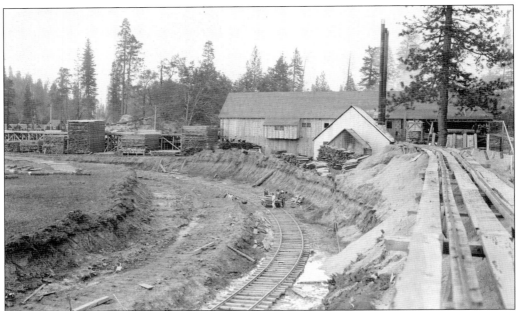

The south side of the sawmill is depicted in this c. 1920 photograph. The 4-foot-thick layer of loam on the left of the picture was stripped away in order to obtain the gravel below. This material was later used for ballast on the rail line. A naturally occurring spring waters the area, and the gravel pit would quickly fill. While construction was ongoing, the water was pumped off-site. Later the area would be allowed to fill with water, becoming Birch Lake. (Courtesy of San Francisco PUC.)

Another view of the gravel pit is shown here. The sawmill is located on the left. A steam engine, with its load of logs slated for delivery to a nearby millpond, is shown on the right. In the center of the picture is the ever-expanding pile of sawdust generated by mill operations. (Photograph by Horace B. Chaffee; courtesy of San Francisco PUC.)

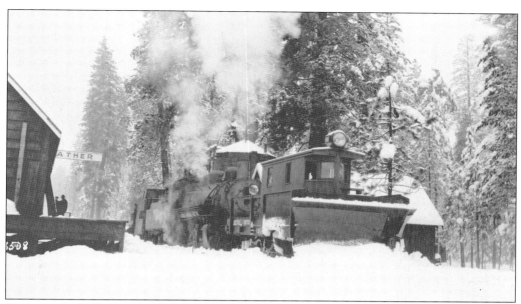

Crews worked all year-round, even during heavy snowfall, which made for difficult travel to Damsite, the name given to the work camp established above the Hetch Hetchy Valley floor. City crews fashioned their own snowplows for use on specially equipped trains and vehicles. Here the snowplow is clearing the tracks at Mather Station to ensure the steady movement of equipment and supplies. (Photograph by Horace B. Chaffee; courtesy of San Francisco PUC.)

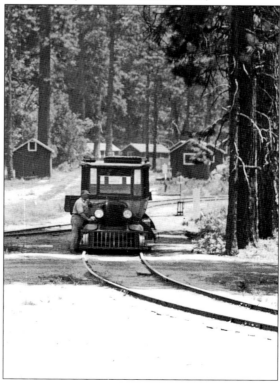

It is now 1924. The railroad was completed in 1917; the dam was finished by April 1923. Because San Francisco would not receive any water from the project until 1934, there was still work to be done on the hydroelectric system, the facilities at Cherry Creek, and the system of tunnels and aqueducts that would carry the waters of the Tuolumne River across the San Joaquin Valley. A few years earlier, a quiet scene like this one would have been impossible to find because crews worked 24 hours a day year-round to construct the dam. (Courtesy of San Francisco PUC.)

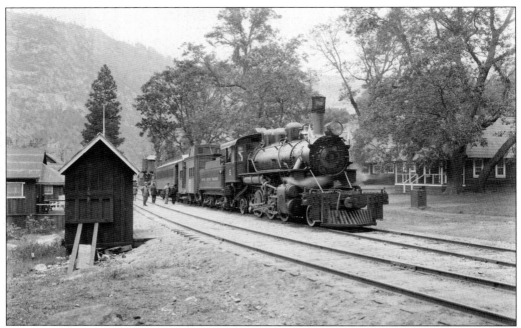

Completion of the Hetch Hetchy Railroad made it possible for both supplies and passengers to be brought to the dam site. Here steam engine No. 5 is shown with a caboose and a single passenger car. It was not uncommon for tourists to make the trek from San Francisco or Yosemite to Mather Station and the valley to observe construction activities. (Photograph by Horace B. Chaffee; courtesy of San Francisco PUC.)

It is a beautiful day in 1923, and the passengers on Hetch Hetchy Railroad bus No. 21 make a brief stop at Mather Station before returning home. Regular weekend excursions were operated for all sorts of groups from the city. For $29.80, a visitor would receive a Pullman berth, meals, and a Saturday stay at the Yosemite National Park Company's lodge, which is now Camp Mather's dining hall. (Courtesy of Tuolumne County Museum.)

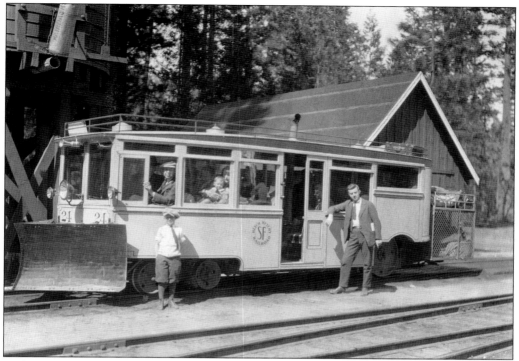

Railbus No. 24, specially fabricated in San Francisco, pauses in front of the water tower at Mather Station. Capable of speeds up to 50 miles per hour, these gasoline-powered passenger vehicles could double as a hospital car in an emergency. A lucky young boy stands near the permanently attached snowplow wondering when they will be hurtling down the rails once more. (Photograph by Horace B. Chaffee; courtesy of San Francisco PUC.)

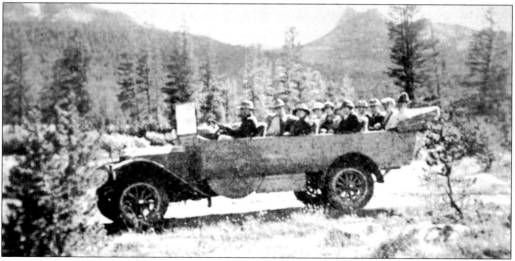

Completion of the railroad in 1917 reduced the travel time from San Francisco to Mather Station to a mere 14 hours. Roads had been somewhat improved. Inspection parties of the San Francisco Board of Supervisors and Grand Jury often visited the area. Open-air Pierce Arrow touring cars replaced the horse-drawn stages used just a few years earlier. (Courtesy of Richard Schadt.)

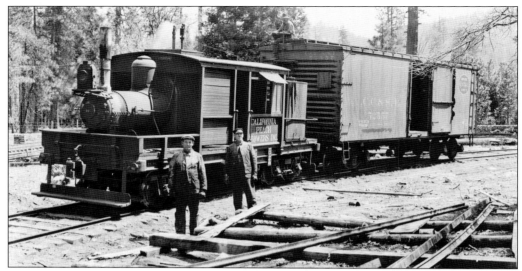

Between 1918 and 1925, the largely unknown California Peach and Fig Growers Railroad (CP&FG) rolled along some six miles of tracks through a heavily forested area in what is now the Middle Fork Day-Use Area. When the Hetch Hetchy Railroad became a common carrier in 1918, CP&FG was able to bring its finished product to the rail junction at Hog Ranch for subsequent transport to the Central Valley. The California Peach and Fig Growers Association had a contract with the U.S. Forest Service to harvest 100 million board feet from Stanislaus National Forest. An additional two miles of rails brought the finished product to the Hetch Hetchy Railroad junction at Hog Ranch. Poor business acumen, inexperienced management, and the less than ideal location of the mill worked against its long-term success. (Photograph by Horace B. Chaffee; courtesy of San Francisco PUC.)

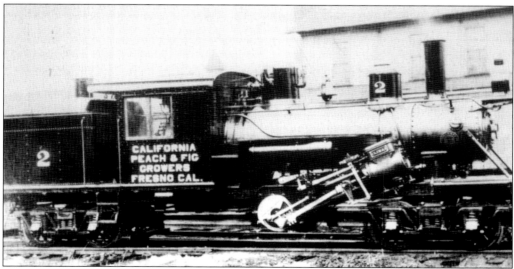

With the blessing of the newly formed U.S. Forest Service, significant amounts of timber were harvested from public forestlands throughout the Sierra. Small but powerful locomotives were indispensable to these lumber operations. This geared locomotive, made by Climax Manufacturing Company, traveled between the CP&FG's mill and its connection with the Hetch Hetchy Railroad at Mather Station. (Photograph by D. S. Richter; courtesy of Sharon Giacomazzi.)

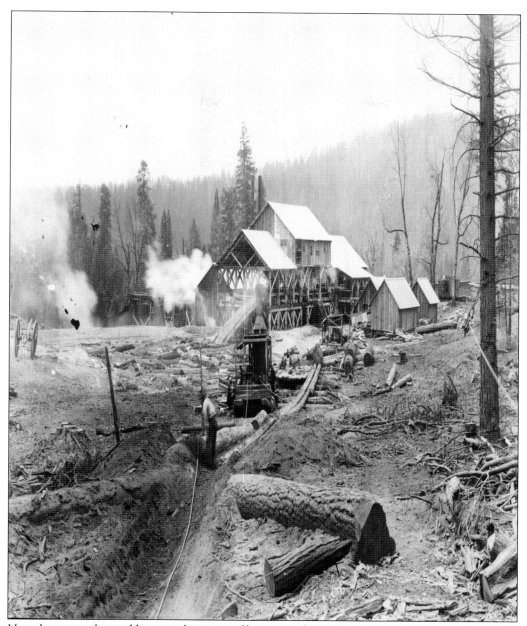

Huge logs were dragged by a combination of horses, mules, and steam engines to the mill where they were sawn to a useable size. The milled timber was then taken to the city's Hog Ranch sawmill, where they were made into shipped crates that were carried by the Hetch Hetchy Railroad to other rail junctions down in the San Joaquin Valley. (Photograph by Horace B. Chaffee; courtesy of San Francisco PUC.)

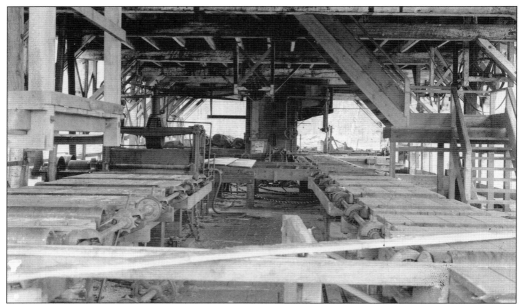

The interior of CP&FG's sawmill is shown in this 1919 photograph. Noisy, dusty, and dangerous, these open-sided mills processed thousands of feet of lumber a day. Subject to the extremes of weather, sawmills of this design were always in a race with time, for with the arrival of the rainy season and the snows that followed, harvesting and milling operations ceased, as did income generated from the sale of processed lumber. (Photograph by Horace B. Chaffee; courtesy of San Francisco PUC.)

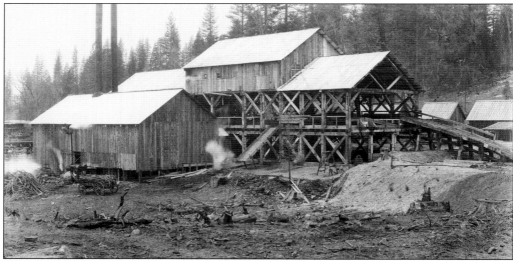

This 1919 photograph shows another view of the sawmill. The association never came close to milling the lumber allowed in its contract with the U.S. Forest Service. Slumping product sales and an unsuccessful attempt to renegotiate carrier fees with the Hetch Hetchy Railroad further aided the decline of the little known rail line and sawmill. The mill burned under mysterious circumstances in 1925. Later that same year, part of the site became an Oakland Boy Scout camp that remained in use until 1972. It is now the Dimond-O Campground, which is part of the Stanislaus National Forest. (Photograph by Horace B. Chaffee; courtesy of San Francisco PUC.)

Four

THE MUNICIPAL CAMP

One of the principal arguments used by the city to gain approval to dam Hetch Hetchy Valley was San Francisco's need for a pure and reliable water supply. Its political efforts came on the heels of the disastrous 1906 earthquake and fire, and thus, the proposal was sympathetically received in many quarters. While the Raker Act obligated the city to provide additional recreational opportunities and trails, the project's chief engineer, Michael O'Shaughnessy, was of the opinion that opening the valley to hordes of campers and tourists would compromise the quality of the city's water supply and therefore resisted any attempts to allow public access to the valley. On the way to the dedication ceremony, San Francisco supervisor Margaret Mary Morgan noticed the Oakland Municipal Camp on the Middle Fork of the Tuolumne River and was inspired to investigate options for establishing a camp on land already acquired by the city for the Hetch Hetchy Project. With the backing of the "Chief" and her colleagues on the board of supervisors, legislation was passed establishing San Francisco's municipal camp at Mather. The early core of the camp was cobbled together from existing camp buildings purchased earlier from the Yosemite National Park Company. Portions of the new camp coexisted with the decaying remains of the sawmill and construction site, and it would take many years and the collective efforts of numerous individuals to create the Mather known today.

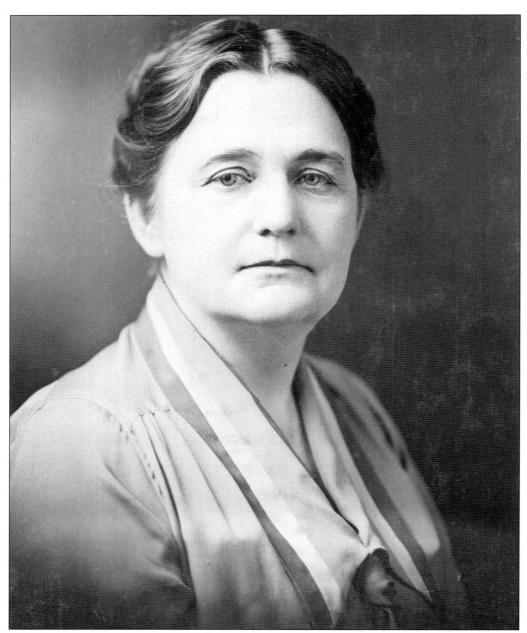

Margaret Mary Morgan was a remarkable individual. Known for her keen sense of humor and sparkling wit, she was a strong advocate for greater participation in politics by women. In 1919, she became the first woman elected to the board of supervisors. Her 1923 resolution requested that the city engineer do a survey of the land being used for the Hetch Hetchy Project and select a site suitable for a municipal camp. In the early years of the camp, it was known as Margaret Maryland in honor of her work to establish a campground for San Francisco. Finally dedicated in May 1924, it was financed and operated by the city's playground commission. (Courtesy of San Francisco History Center, San Francisco Public Library.)

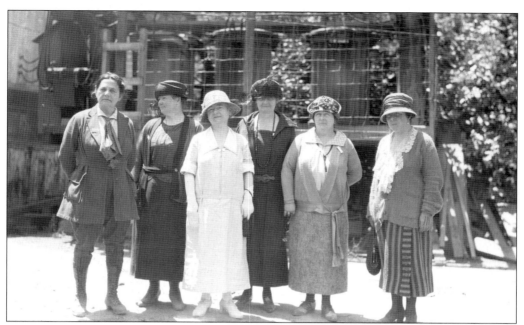

In this 1923 photograph, supervisor Margaret Mary Morgan (far left) is shown with other city women, including Grace Mabel Allen Rolph, the wife of Mayor Angelo Rolph (white dress, third from left) at Early Intake, the site of the hydroelectric station that was used to provide power to the dam site. Morgan successfully operated her own printing business in San Francisco for many years. (Courtesy of San Francisco PUC.)

Alicia Musgrove unsuccessfully ran for supervisor after Margaret Morgan was not re-elected. She worked hard for increased recreational opportunities throughout the city, was actively involved with the Camp Fire Girls, and continued to improve and upgrade the facilities of the municipal camp while a member of the playground commission. Statewide, she advocated for penal reform for incarcerated women. (Courtesy of San Francisco History Center, San Francisco Public Library.)

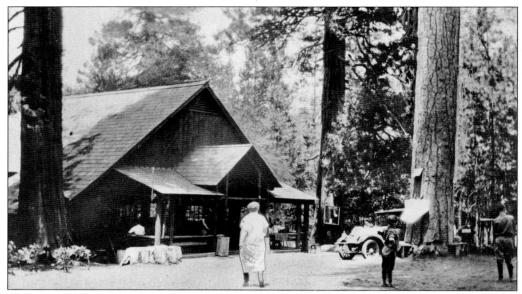

The original dining hall was part of a concession established by the Yosemite National Park Company to feed and house visitors to the area interested in touring the dam site. In addition to the dining hall, there were 24 cabins, a bathhouse, and a kitchen. Known as Hetch Hetchy Lodge, the city purchased the facilities in 1925 for $15,000. (Courtesy of San Francisco History Center, San Francisco Public Library.)

Over the years, the simple, log structure design of the entrance to the camp would remain a constant; only the details would change. A gate existed for a short time. Stone pedestals and a cattle guard were added later. A variety of horizontal boards announcing the name of the camp came and went. In this winter scene of the portal, the sign reads Hetch Hetchy Lodge, indicating that it dates from the 1920s. (Courtesy of Tuolumne County Museum.)

A 1924 photograph shows Birch Lake starting its transition from sawmill to prime recreation spot. A small raft floats serenely in the center of the lake. A serviceable dock affords easy access to the waters and a place to dry off after wading, swimming, or boating. Worker cabins are seen in the background. During the ensuing decades, these same cabins would house multiple generations of San Francisco families who made the 180-mile summer trek to the camp. (Photograph by Horace B. Chaffee; courtesy of San Francisco PUC.)

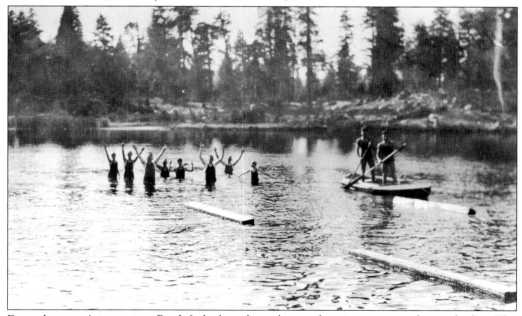

From the camp's inception, Birch Lake has always been a favorite spot to gather and relax. The lake and the surrounding meadow area would undergo numerous improvements and changes over the years as the camp evolved. The inviting water temperature, sunny skies, and Sierra setting have made Birch Lake irresistible for over 84 years. The shallow depth of the lake, shown in this 1927 photograph, did not deter this group of swimmers, nor, it would appear, did the many years of accumulated silt measuring several inches that coated the sand and gravel bottom of the lake. (Photograph by Horace B. Chaffee; courtesy of San Francisco PUC.)

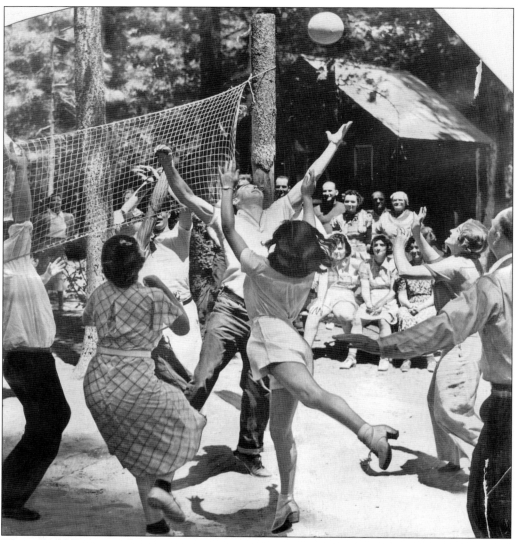

The volleyball court is the place to be at Mather in 1928. The match is intense, and the pressure is on. Long dresses and pumps do not seem to interfere with the level of play as the players follow the travel of the ball. An afternoon crowd has gathered to cheer the teams on as each side continues to make one incredible save after another. (Courtesy of San Francisco History Center, San Francisco Public Library.)

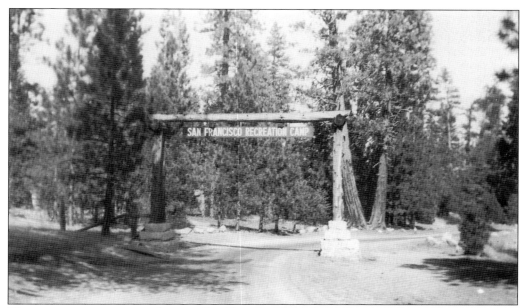

The entrance now carries the sign San Francisco Recreation Camp, most likely marking the opening of the camp's first season in 1924. The camp occupied mainly the area south of the Hetch Hetchy Railroad tracks and included the cabins, cookhouse, and other facilities previously used by workers. The city's initial year of operation allowed for 80 to 100 guests at a time. A total of 400 visitors visited the camp during its first season. (Courtesy of the Dan Dempsey family.)

In establishing a recreational camp, the playground commission wisely used whatever resources were available to it—on site or off—to provide lodging and other amenities to make the camp appealing. These cottages were once used as polling stations in the city and were brought to the camp to serve as guest housing. Their canvas roofs were later replaced, and they are still in use today as cabin Nos. 1 through 25. (Photograph by Horace B. Chaffee; courtesy of San Francisco PUC.)

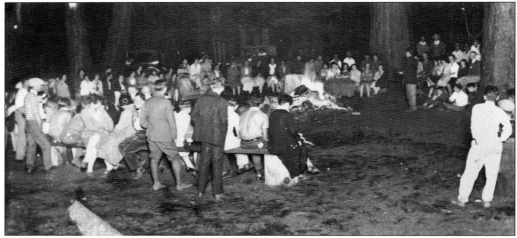

The brochure produced for the first season advised that, "Every San Franciscan should make it his business to give the family an outing at this Municipal Camp." A 14-day trip cost an adult $35 and included board, lodging, and transportation. Children under 12 were charged $21; kids from two to five, $11. The highlight of every visit was the huge campfire on the grounds near the dining hall. This 1927 audience enjoys the warmth and spectacle of the fire ceremony as the first evening at camp comes to a close. (Photograph by Horace. B. Chaffee; courtesy of San Francisco PUC.)

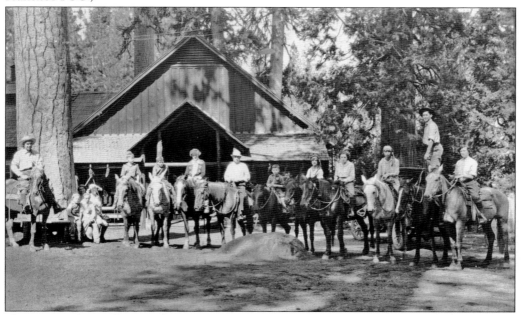

The San Francisco Playground Commission managed and operated the camp. Brochures produced for the 1926 season promoted the experience as an ideal vacation filled with wonderful activities for visitors of all ages that included hiking, fishing, horseback riding, and exploring. After an informal arrangement to operate the Back Pack and Saddle Horse concession proved problematic, a formal agreement was drawn up between the commission and the Yosemite Park and Curry Company. In this 1927 photograph, a group gets ready to set off on a side trip around the grounds of Mather. (Photograph by Horace B. Chaffee; courtesy of San Francisco PUC.)

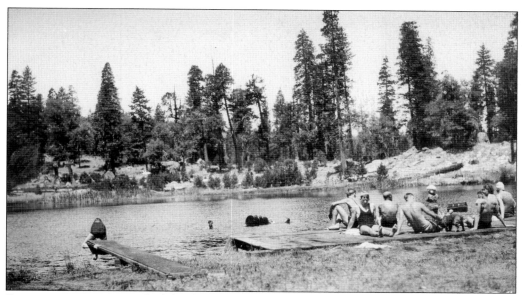

Sparse vegetation across the lake, few specimen trees in the background, the small crowd, and a rustic dock combine in this 1929 photograph illustrate a much smaller Birch Lake in its early days. (Courtesy of Groveland Ranger District, Stanislaus National Forest.)

A shallow swimming tank had been installed in the area formerly used as a millpond. Over the years, the pool would be relocated several times and the design changed accordingly. The rail trestle can be seen in the background, a reminder that not long ago the sound of Shay steam engines and the whine of saw blades could be heard echoing throughout the camp. (Courtesy of Garrison family collection.)

The weeds growing up around the track in 1925 seem to suggest that the glory days of the Hetch Hetchy Railroad are drawing to a close. The mill no longer operated because the dam was nearing completion, and construction of the electrical and water supply elements of the project was centered well away from Mather Station. The city would terminate rail service between Damsite and Mather, remove the tracks, and pave the former right-of-way for automobile use per the Raker Act. The design of the road would remain a contentious issue between the National Park Service and the city for years to come. (Courtesy of Garrison family collection.)

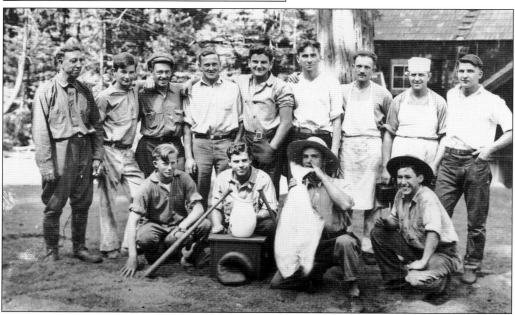

Many adults who worked at the camp during the summer were employees of the playground commission during the remainder of the year. Norman Center (back row fourth from left) was director of the swimming department when he was appointed camp manager in January 1927. With the assistance of Alicia Mosgrove and other members of the camp committee of the playground commission, he set the tone for development of the camp from its early days. He remained manager for 27 years until his retirement in 1953. (Courtesy of Garrison family collection.)

Five

SIDE TRIPS

During the early days of the 20th century, considerable discussion by progressives of the day focused on the benefits of getting people out of the cities to renew themselves in the great outdoors. Urban enclaves at that time were unhealthy places: air pollution was rampant, sanitation was elementary, and houses were closely crowded together. Reconnecting with nature was felt to be the perfect tonic for the deplorable conditions of most major cities. The railroads promoted trips to Yosemite National Park and other scenic areas in the Sierra. Enterprising developers built resorts to capitalize on the back-to-nature trend. With cars, people could now seek out less popular sites and enjoy a peaceful stay in the woods. About 1916, the Carl Inn was built on a flat near the Tuolumne River's South Fork. Despite occasional fires, the inn managed to attract sufficient clientele to make it a thriving venture. Cabins or tents were available to houseguests; a dance floor and soda fountain were there to amuse them; and an on-site service station was staffed with reliable mechanics. The inn briefly housed the families of civilian and defense workers assigned to Camp Mather during World War II. The land was purchased by the U.S. Forest Service in the late 1930s, and the inn was torn down in 1942. Careful inspection of the area on either side of the present Carlon Falls Day-Use Area reveals the remnants of this popular resort.

The Cliff House was another unique venture sited on the south fork of the Tuolumne River. Situated in an area with inviting pools and a waterfall, the Cliff House succumbed to fire on more than one occasion and was rebuilt each time. An early gathering spot for Hetch Hetchy project workers, it later became a requisite stop for travelers on their way to Mather and points beyond. Weary passengers could take a refreshing break by enjoying a cool drink served from a cave on the property. The inn eventually became the Rainbow Pools Picnic Area and is a popular day-trip destination for Mather campers. The mill of the California Peach and Fig Growers Association was short-lived and plagued by a host of problems. In 1926, the Oakland Area Council's Boy Scout camps purchased the improvements that comprised the entire camp and mill site; the first group of Scouts arrived at Camp Dimond-O that year. It continued to operate as a scouting camp until 1979 and is now the Dimond-O campground, a recreation unit of Stanislaus National Park.

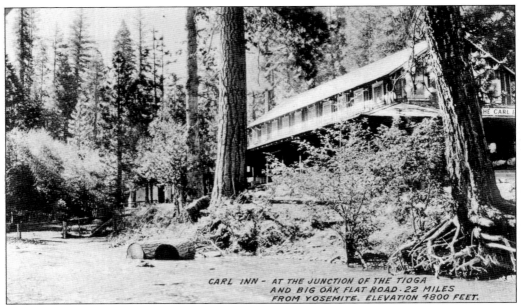

CARL INN - AT THE JUNCTION OF THE TIOGA AND BIG OAK FLAT ROAD. 22 MILES FROM YOSEMITE. ELEVATION 4800 FEET.

In 1916, an enterprising couple, Dan and Donna Carlon, established the Carl Inn resort at a grassy flat adjacent to the South Fork of the Tuolumne River in what is now the Carlon Falls Day-Use Area. The development of the resort coincided with the activity at Hog Ranch, and the location of the inn at the intersection of three key Sierra roads that led to and from Yosemite made the inn a popular tourist destination. It consisted of a lobby, dining room, several cabins, and a numerous tents. Fire destroyed the first inn in 1920. (Courtesy of Groveland Ranger District, Stanislaus National Forest.)

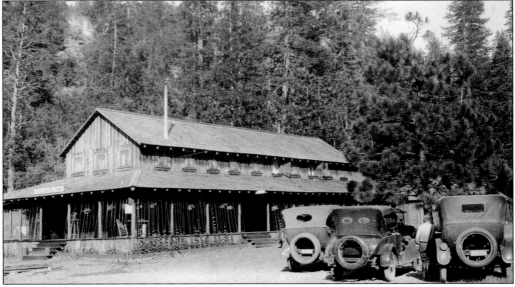

The inn was rebuilt in time to capitalize on the rise of automobile travel brought about by improved, all-weather roads. It was later expanded to include an outdoor dance pavilion and soda fountain. Additional cabins and tents were located on a hill overlooking the meadow. (Courtesy of Tuolumne County Museum.)

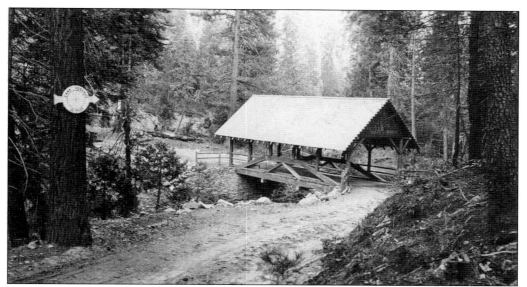

This 1918 photograph shows the junction of the Tioga Road and Big Oak Flat Road, two of the principal access routes to Yosemite Valley. A wooden, covered bridge crosses a small stream. The directional sign on a nearby tree reads, "Camp Yosemite 22 miles."

After the inn was again destroyed by fire in 1927, the owners of the resort forged ahead with more improvements, including their own garage. The sporty convertible and the coupe shown in this 1937 picture are parked in front of a "pump block," which was provided by Standard Oil of California and replaced the earlier gasoline station. (Courtesy of Groveland Ranger District, Stanislaus National Forest.)

AUTOMOBILE ROADS
FROM
CARL INN
TO
TIOGA LODGE
COPYRIGHTED BY THE
CALIFORNIA STATE AUTO. ASSN.
80 VAN NESS AVE. SAN FRANCISCO CALIF.
SCALE IN MILES

NOTE: CAMPING GROUNDS MAINTAINED BY U.S. FOREST SERVICE SHOWN THUS: ⊕

O'SHAUGHNESSY DAM. Tuttill Cr. Rancheria Cr.
HETCH HETCHY RESERVOIR.
TUOLUMNE RIVER
Cottonwood Cr.
Entrance Station
MATHER
EVERGREEN LODGE
of Tuolumne River
Tuolumne River
Morrison Cr.

TO LAKE ELEANOR
TO BRIDGEPORT FROM TIOGA LODGE 23 MI

LUNDY
Lundy Mill Cr.
Lundy Lake
Saddlebag Lake 00 69
MONO INN
TIOGA LODGE

68 1
9 60
19
WHITE WOLF LODGE
15 54
CAMP TIOGA
EL 9800
LEEVINING
3 66

63 6
50
CARL INN
39 00
ASPEN VALLEY LODGE
Entrance Station
South Fork of Tuolumne River

Leevining Cr.
Ellery Lake
Tioga Lake
TIOGA PASS ELEV 9940
LEEVINING RANGER STA.

17 52
32 37
Soda Spring
TUOLUMNE MEADOWS
Entrance Station
TUOLUMNE MEADOWS LODGE
23 46

TUOLUMNE GROVE BIG TREES
MERCED GROVE BIG TREES
CRANE FLAT
Cascade Cr.
Yosemite Cr.
Snow Cr.
Tenaya Cr.
Tenaya Lake ELEV 8141'
Meadows
Lyell Cr.
Rush Cr.

Entrance Station
TO YOSEMITE FROM ENTRANCE STATION 13 MI.

THIS MAP ISSUED BY SAN FRANCISCO OFFICE
CLERK
DATE

NOTE: FIGURES IN CIRCLES INDICATE MILEAGE FROM TIOGA LODGE – FIGURES WITHOUT INDICATE MILEAGE FROM CARL INN

TO BISHOP FROM TIOGA 67.5 MILES

—Paved Highways and Oiled Roads
BLUE—Gravel or D...

From about 1918 to 1926, the California State Automobile Association maintained a tent emergency station about three miles beyond the Carl Inn resort on the road to Yosemite. Many a worried club member was rescued by a tow truck, cooled down an overheated engine, or made critical repairs with the help from the emergency road service. This handy map from 1931 shows the existing automobile roads between the inn and Mono Lake on the eastern side of the Sierra.

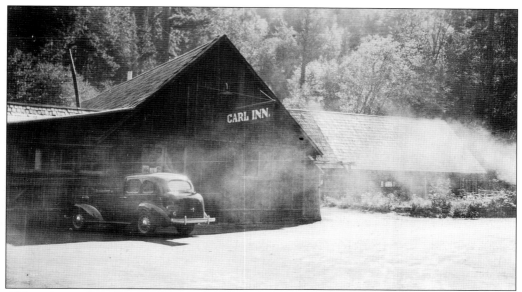

Although many roads were improved and oiled by the time this early-1930s picture was taken, once a traveler left the main road, conditions quickly changed. The lingering dust shown swirling around the inn is a reminder of how exciting auto travel was in the early 20th century. The inn ceased operation in 1939 when the forest tract upon which the resort stood was purchased by the federal government and added to Yosemite National Park lands. (Courtesy of Neil Fahy.)

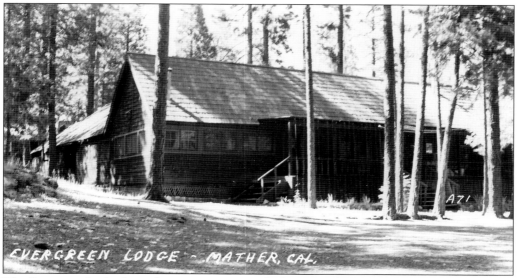

The Evergreen Lodge has a long connection with Camp Mather. Lore has it that the original idea and beginnings of the lodge were those of a worker on the Hetch Hetchy Railroad. The original structure (no longer standing) had one room, no internal framing, and a heating stove yet somehow withstood the annual snow loads. (Courtesy of Neil Fahy.)

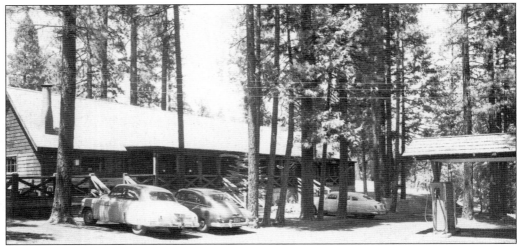

The Evergreen Lodge appealed to workers in the area both during the peak construction years and those that followed. It had a grocery store, offered off-sale liquor, and featured three slot machines. A dance floor was added later. Many guest fondly remember the wonderful soda fountain that was removed in the 1950s. The soda fountain now resides in Columbia State Historical Park. The marble tabletops in the dining room were once urinal partitions in the men's room at San Francisco's Fleischacker Zoo. A careful look at the lodge railings, shown in this late 1940s postcard, reveals the "X-in rectangle" design that one-time owner Jack Garrison achieved by recycling railroad ties scavenged from the old Hetch Hetchy and CP&FG railways.

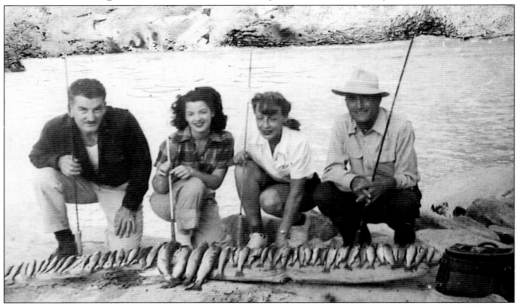

By all accounts, it was truly a special time when the Evergreen Lodge was owned by Jack and Katherine Garrison. They made substantial improvements in the lodge, including kitchen improvements and an outdoor barbecue area. From left to right, Jack Garrison, Margie ?, Katherine Garrison, and ? Rovero proudly show off the day's catch of trout from the Middle Fork of the Tuolumne River, undoubtedly destined for some lucky guest's plate. (Courtesy of Garrison family collection.)

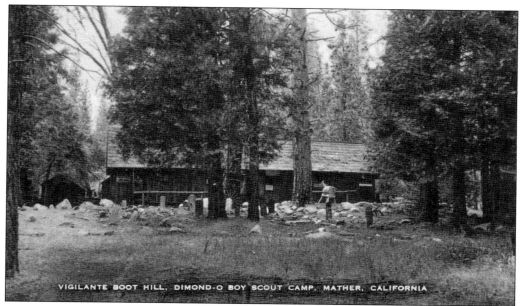

VIGILANTE BOOT HILL, DIMOND-O BOY SCOUT CAMP, MATHER, CALIFORNIA

Just down the road from Evergreen Lodge and Camp Mather was the Dimond-O Boy Scout camp. It was built on a portion of the old California Peach and Fig Growers sawmill site. "Vigilante Boot Hill" refers to a Boy Scout ritual that honored the scout of the week with a carved tombstone that was placed in the "cemetery." Use of the grounds as a Scout camp was discontinued in 1979. In 1994, the Dimond-O campground was opened on the site. The campground was sensitively developed and sited to protect fragile resources and to allow the recovery of those areas damaged by previous overuse.

Coming around the bend, the sight of the old bridge and the Cliff House meant welcome relief to weary and thirsty travelers. Ideally situated next to the river and the pools, it offered motor court accommodations for short-term visitors and cabins for those wishing to have an extended stay. (Courtesy of Groveland Ranger District, Stanislaus National Forest.)

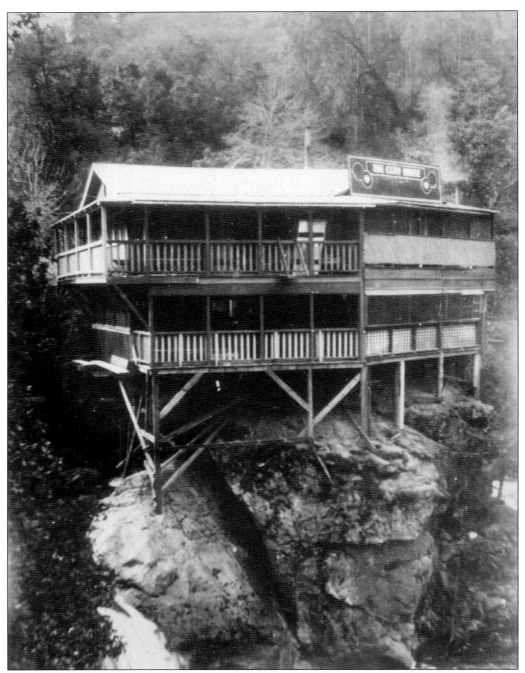

The Cliff House lodge on Highway 120 was a popular resort stop in the 1920s–1930s. When it was first built in 1924, it received heavy patronage from crews working on the Hetch Hetchy Dam. Located adjacent to the South Fork of the Tuolumne River, it was well known for its weekend dances. This two-story version in the 1930s lasted until the lodge burned down in 1939 and was replaced by a single-story design. (Courtesy of Groveland Ranger District, Stanislaus National Forest.)

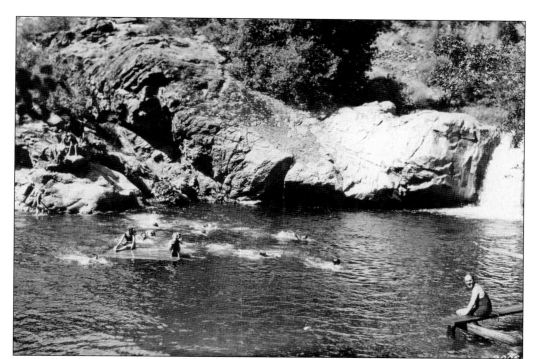

As early as the 1920s, visitors were attracted to the rushing waters, warm rocks, and exciting waterfalls of Rainbow Pools, located on the South Fork of the Tuolumne River. The platform in the center of the pool makes for a great spot to rest or play king of the mountain. (Courtesy of Groveland Ranger District, Stanislaus National Forest.)

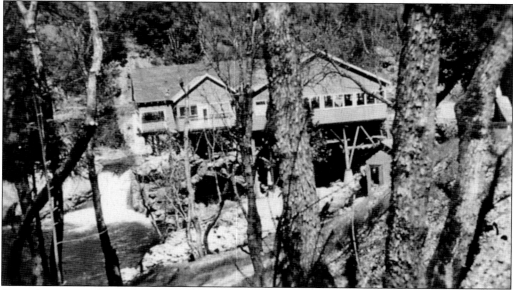

Over the years it was in operation, the Cliff House offered a snack bar, gas station, cabins, and a dance floor. The picturesque waterfall and natural pool drew many bathers, some of whom were daring enough to jump from the lodge into the pool. (Courtesy of Groveland Ranger District, Stanislaus National Forest.)

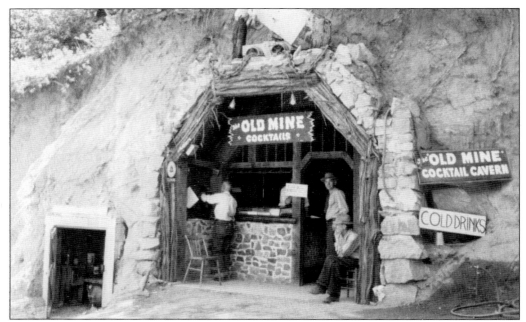

Surely one of defining features of the Cliff House was the cocktail lounge in the cave. If customers traveling up from the valley during the summer were not attracted by its uniqueness, the lure of cold drinks served from deep within a hillside was irresistible. As it was one of the few stops on the highway, it made perfect sense to take a break to enjoy a beverage and the wonderful view of the river before continuing on one's journey. (Courtesy of Groveland Ranger District, Stanislaus National Forest.)

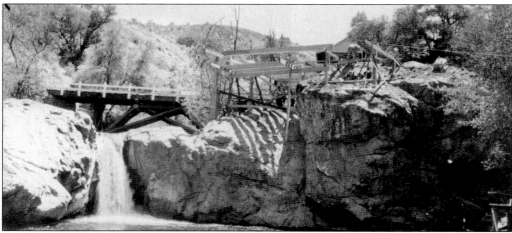

Fire was always a threat to the resort. It burned down in 1939, 1957, and 1962. The last fire, and the relocation of Highway 120 with a modern bridge that bypassed the resort, spelled the end of the Cliff House. It is fondly remembered by those fortunate enough to have visited the site in its heyday. This 1939 photograph shows the rebuilding progress being made on the facility after yet another disastrous fire. In 1963, the U.S. Forest Service special-use permit was not renewed, and the Cliff House site was cleared. The area is now a popular destination managed by the U.S. Forest Service known as the Rainbow Pool recreation site, and few remnants of its former use exist today. (Courtesy of Groveland Ranger District, Stanislaus National Forest.)

Six

CAMP MATHER

By the early 1930s, Camp Mather was beginning to take on the appearance of a well-run municipal facility. The San Francisco Recreation Commission created brochures describing the experiences that awaited visitors to the camp; local newspapers ran human-interest stories depicting life at Mather; and by word of mouth, residents of the city were telling friends and neighbors of the wonderful time to be had at this marvelous Sierra camp. Even during the Depression and World War II, the camp remained operational. With the end of the war and the economic boom that followed, Mather became the place for families to bring their children and spend a week or two in the woods. For many residents, the annual trek to Camp Mather became a tradition unbroken for years. Occasionally, new ideas were put forth to establish other recreation facilities in the area or expand existing ones. The city had acquired the Ike Dye Place with the idea to make it into a children's camp. Plans were routinely developed for a winter program at Mather. A management plan drawn up by architect William Merchant called for the construction of a 100-room lodge at the north end of Birch Lake. None of these proposals reached fruition, and they were soon forgotten. Life at the camp was clearly egalitarian. Elected city officials stood in line just like everyone else. Supreme Court associate justice Stephen Breyer, who as a young man worked in the camp, noted that the best part of life at camp was that "it was a democratic experience—families and children had a chance to enjoy the outdoors." Tales of horse rides, days at Birch Lake, talent shows, hikes to Inspiration Point, bears wandering through camp, and wonderful meals in the dining hall are just some of the memories that remain vivid today.

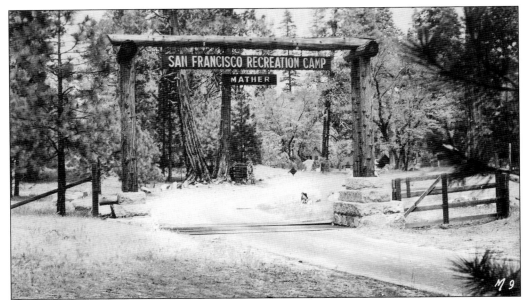

A new sign greeted visitors to the camp, announcing that henceforth it would be known as Camp Mather. It is 1932, and the country is in the midst of the Great Depression. Money is tight, yet Mayor Angelo Rossi, in conjunction with other city departments and the Works Project Administration (WPA) of the federal government, managed to create 60 jobs to carry out projects at Mather. (Courtesy of Neil Fahy.)

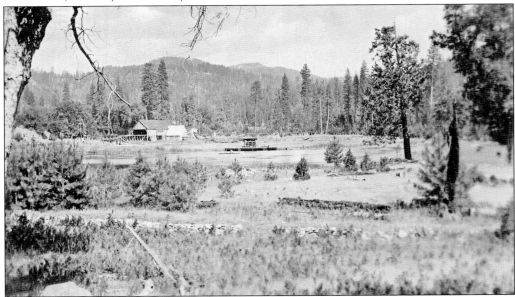

Although conditions around Birch Lake were slowly improving, it would take many years to erase the impacts of the construction camp. Operations at the sawmill have ceased, and the empty building, silent and still, was a testament to a different era. Equipment from the mill has been removed and taken to Mocassin, the power-generating facility below Priest Grade. The vacant building will remain attractive as a place for children to explore until it is demolished in 1933. Several thousand cubic yards of sawdust were also removed. (Courtesy of Garrison family collection.)

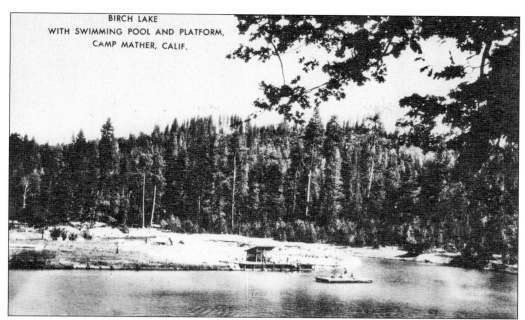

BIRCH LAKE
WITH SWIMMING POOL AND PLATFORM,
CAMP MATHER, CALIF.

Among the first jobs for the new work crews to tackle was a major renovation of Birch Lake. About 4,000 cubic yards of silt and material were removed from the lake and spread between the lake and the old railroad tracks. Any gravel recovered was used to surface camp roads and for the tennis courts. The lake was deepened, cleaned, and enlarged by 10 feet around its perimeter.

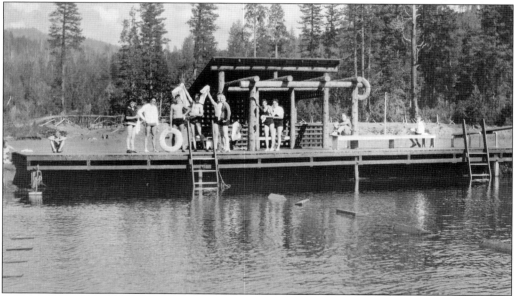

A few hearty souls get ready for a bracing swim in the early morning hours of 1932. The newly refashioned dock and wooden shelter were welcome improvements to the area and quickly became the prime spots at which to pass the day at Birch Lake. Additional amenities would be developed in the coming years, including landscaping the area impacted by the mill, creating a large expanse of lawn, providing tennis courts, and a installing a plunge. (Courtesy of Garrison family collection.)

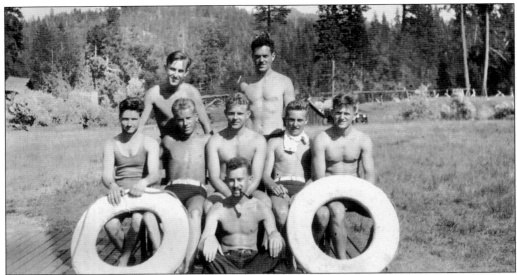

A summer job as a lifeguard at Birch Lake has always been an attractive position. Many former lifeguards returned to camp to assume other responsibilities. This group of water safety specialists enjoys a relaxing moment before reporting for their assignments. The absence of female lifeguards in this group picture reflects city policy, which did not permit young women to be employed at the camp until the late 1940s. (Courtesy of Garrison family collection.)

The camp staff was predominantly male. Acting as general laborers, truck drivers, or jacks-of-all-trades, employees performed a variety of tasks to keep the camp running. The Hetch Hetchy Water and Power Division had access to tools and machines from which replacement parts could be fashioned in an emergency, but resourcefulness was the hallmark of a good staff assistant. Here a group of four pals takes a break by Birch Lake before returning to their afternoon assignments. From left to right are unidentified, Harry Finnegan, Tom Flanagan, and Charley Garrison. (Courtesy of Garrison family collection.)

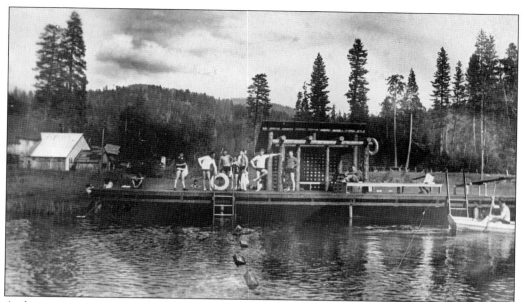

A glorious moment at Birch Lake is captured for posterity. The mill complex stands silently on the left; a solitary boater oars in from the right; the Sierra sky reflects on the calm surface of the lake; and a small group of lucky campers happen to be in the right place at the right time. (Courtesy of Garrison family collection.)

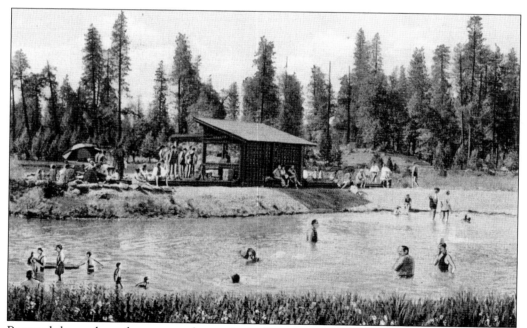

Postcards have always been a popular method of letting the folks back home know what a good time one is having on vacation. The camp and its most easily recognizable landmarks—the entrance gate, the dining hall, and Birch Lake—were the subject of many postcards. This fancy embossed example shows an interesting view of Birch Lake in the 1930s that prominently features the dock and wading areas.

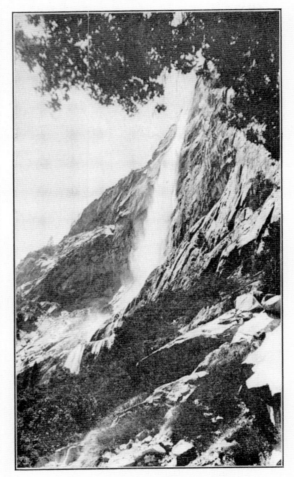

SAN FRANCISCO'S MOUNTAIN CAMP MATHER

[*On the Tuolumne River Gorge at*]
[MATHER, CALIFORNIA]
ELEVATION 4500 FEET

Vacation in the High Sierra
June 10th to September 2nd, 1933

Under the Management of the
San Francisco Recreation Commission

UNderhill 2406 ROOM 370, CITY HALL

Tueeulala Falls in the Hetch Hetchy Valley is centrally displayed on the cover of the 1933 Camp Mather brochure. The elaborately designed pamphlets featured numerous photographic scenes of the area, as well as descriptive information about camp life. (Courtesy of Neil Fahy.)

ROUTE TO SAN FRANCISCO RECREATION CAMP

This simple map was included with the camp brochure and provided a thumbnail sketch of the journey from San Francisco to Camp Mather. It also served as a useful diversion for the kids and was a visual answer to the oft asked question, "Are we there yet?" (Courtesy of Neil Fahy.)

LOCATION

Camp Mather is located among cool evergreen forests and rolling mountain meadows at an altitude of 4,500 feet on the rim of the Grand Canyon of the Tuolumne. Here in the High Sierra Forest, stream and lake beckon the vacationist who enjoys horseback trips into virgin back country, invigorating hikes along scenic mountain trails, or stream and lake fishing, for which this country is famous.

Among the many points of interest in the vicinity are:

Muir Gorge, 5,000 feet deep, Laurel, Vernon, Benson and Rodger Lakes, lying at altitudes of between 6,000 and 10,000 feet. Tuolumne Meadows, Lake Tenaya and Mono Lake, via the Tioga Pass and Levining Grade, all are but a day's trip by motor, and the Yosemite Valley is 30 miles from Camp.

The great O'Shaughnessy Dam and Hetch Hetchy Reservoir, encircled by towering cliffs and fed by tumbling waterfalls, are nine miles from the Camp, and accessible by trail, horseback or motor.

• •

RECREATION

Games

Facilities and equipment for baseball, volleyball, horse shoe pitching, ping pong, croquet and tennis are at the disposal of the guest without charge.

Two concrete surface, double tennis courts have just been completed and the tennis enthusiast will find them to be really excellent courts.

Swimming

Birch Lake has been greatly improved for this season's use. It was pumped completely dry in the Fall of 1932 and a silt deposit of fifteen years' accumulation which had coated the sand and gravel bottom to a depth of several inches was completely removed, banks were trimmed and a lagoon 150 x 100 ft. was added to the lake's area. The lake holds 30,000,000 gallons of spring fed water. Its banks and bottom are of the finest sand and gravel. The lagoon is completely surrounded by a beautiful white sand beach and the same white sand carpets its complete area. Its depth is graduated to that of a gently sloping ocean beach.

The concrete plunge on the lake's margin 3 ft. 5 ft. deep, 50 ft. by 60 ft. in dimension is ideal beginners and supplements the lagoon in this resp

The area formerly covered by the Hetch Hetchy S Mill structure has been completely cleared and resto to its natural state by the planting of native shrubs vines. This area is now one of the most beautiful s in camp. The new tennis courts are located here.

Hikes and Nature Study

The many miles of beautiful trail for hikers have b added to by a beautiful new Canyon Rim trail. camp guide and naturalist conducts scheduled na study hikes and has prepared an excellent exhibi properly catalogued flora, rocks, butterflies, etc. for information and study of those who are interested. bird sanctuary offers excellent opportunity for study and photography.

Trips

An outstanding feature quite appropriate to rugged mountain camp atmosphere is the opportu afforded guests for taking pack train trips into mountains and surrounding lake country. All food provisions for these trips are supplied by the C Commissary without charge, the rent of the horses b the only fee required. Guide service and pack equipment are included in the rental of horses. Ri horses are available at Camp by the hour or da moderate rates.

Moonlight and breakfast rides with supper sizzling steak and breakfast of biscuit, bacon and and fragrant coffee prepared by the guide are feat of the Riding Concession Service.

Park Curry Company motor buses convey Camp gu to various points of interest in the vicinity. Spe tours are arranged by the Camp management at nominal rates.

Entertainment

Under the supervision of the camp hostess ga tournaments, masquerade dances, whist and bri parties are arranged.

Amateur theatricals, impromptu song and stor weenie and marshmallow roasts around the rollic evening camp fire complete a perfect day.

The San Francisco Recreation Commission went to great lengths to extol the virtues of Camp Mather. This page from a 1933 brochure speaks well to the benefits derived from booking a two-week stay at the camp. Everything a family could want and need seems to be available at Camp Mather, including daily mail service. Dress clothes are discouraged as they are "out of place."

ACCOMMODATIONS

Cabins

Modestly furnished rustic cabins suited to the size of the family or group assure comfort and privacy. Each cabin is electrically lighted, equipped with wardrobe facilities and steel spring single beds furnished with excellent mattresses and pillows. Guests must supply all bedding and linen.

There is no water in the cabins. Strictly modern sanitary appointments conveniently situated to each group of cabins afford showers, basins, and tub baths, with an abundance of electrically heated water at all hours.

Lodge

The Lodge, situated in the center of camp, provides large assembly room with an open fireplace, music facilities and library.

Conveniences

Beverages, candies, tobacco, toilet articles, postcards, stationery and daily papers and magazines are procurable at the camp store.

Laundry facilities are provided—concrete wash tubs, ironing boards, an abundant supply of hot water and base board plugs for electric irons.

There is a daily mail service.

There is a pay station telephone service.

First aid and medical service are available at all times.

● ●

SAMPLE MENU

In the dining room at the Lodge delectable foods, prepared by culinary experts, are served in unstinted portions, cafeteria style. Modern refrigeration and kitchen equipment facilitate the preparation of foods and insure the freshness of meats and vegetables.

Breakfast: Fruit, cereal, bacon or ham and eggs, hot cakes, toast or rolls.

Luncheon and Dinner: Soup, salad, meats or fresh fish, fresh vegetables and desserts.

Beverages: Coffee, tea, chocolate, postum, iced tea, lemonade and milk.

GENERAL INFORMATION

What to Bring

Bring clothes for "roughing it", high shoes, swimming suit, your camera, your tennis racquet, and if a musician, your musical instrument.

A folding deck chair and hammock will add to your comfort. Camp is not equipped with easy chairs. Bring an extension cord if you read at night.

Do not bring dress clothes unless you wish. They are out of place. Do not bring dogs, cats or birds.

Transportation

Transportation rates by all routes.

Subject to change without notice.

Round trip, adults, 21-day ticket $13.75

Children, 5 thru 12, 21-day ticket 6.90

Children under 5 . Free

Time limit on tickets may be extended by payment of additional fee. Pacific Greyhound buses leave San Francisco from 5th and Mission Streets direct to Camp daily at 11:00 A. M.

Free baggage allowance 100 lbs. on full fare tickets;
50 lbs. on children's tickets;

Baggage limited to 150 lbs. for any one piece.

Special low rates on express.

All buses fitted with comfortable individual reclining chairs. Inquire of Registration Clerk regarding trains.

By your own automobile—

Consult the map on the inside of this folder. Roads to Camp are paved to Yosemite Junction. They are graveled and oiled the rest of the way. The whole route is in excellent condition, and the trip can be made easily in eight hours.

Stay on your side of the road on turns, sound horn, and descend grades in second gear.

Pacific Greyhound buses left San Francisco from Fifth and Mission Streets daily and provided direct service to the camp. If one drove to camp, there were reminders: "Stay on your side of the road on turns, sound horn, and descend grades in second gear." (Courtesy of Neil Fahy.)

In the 1930s, the per diem board and lodging rate for a stay of three days or longer at Camp Mather was $2 for a person 14 years old and over; that now seems like an unbeatable bargain. When compared to the cost of living in 1930, it was not an inexpensive family vacation because round-trip adult bus fare alone was $13.75. A careful study of this chart reveals that for the working class families during the Depression, a vacation at Camp Mather was a major financial commitment. (Courtesy of Neil Fahy.)

PRIEST GRADE as seen from HISTORIC PRIEST'S STATION on the BIG OAK FLAT ROAD Scenic Route To YOSEMITE NATIONAL PARK California

F6686

Travel to camp by private car was an adventure. As one crossed the San Joaquin Valley, stoplights in every small town made the trip slow and time consuming. Upon reaching Mocassin, drivers and passengers alike faced the unenviable journey up old Priest Grade. Boil overs were common on the ascent, and smoking, and sometimes failed brakes, often accompanied the hair-raising descent to the San Joaquin Valley floor.

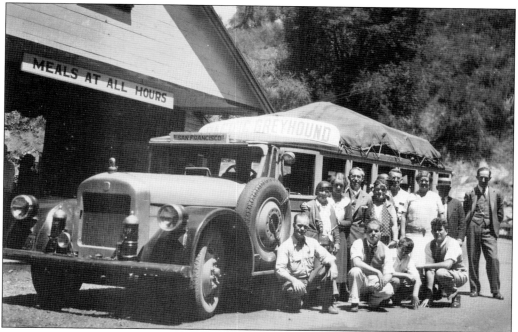

A certain camaraderie developed among passengers who chose to take a Pacific Greyhound "stage" to Camp Mather. This group of nattily dressed travelers enjoys a short stay at the Cliff House, knowing that the end of their journey is in sight and a relaxing week awaits them. (Courtesy of Garrison family collection.)

Once the railroad tracks were removed between Camp Mather and the dam, the city could set about building all-weather roads, thereby fulfilling part of their obligations under the Raker Act. This 1934 photograph shows an automobile headed toward the dam. At the left is the old roadbed of the Hetch Hetchy Railroad. (Photograph by Horace B. Chaffee; courtesy of San Francisco PUC.)

Had permission not been granted to the city to dam the valley, this road leading to Hetch Hetchy might have been part of a loop system that ran from Tuolumne Meadows through Yosemite National Park, down to Mather, then up the valley back to the Meadows via Tioga Road. A resort and other visitor amenities would have been developed to serve the growing number of tourists who would soon discover "Yosemite's twin." (Photograph by Horace B. Chaffee; courtesy of San Francisco PUC.)

This postcard view from the 1930s captures a breathtaking view of the Hetch Hetchy Valley and Reservoir. O'Shaughnessy Dam is perfectly framed in the center of the photograph. Today avid cyclists enjoy these same views as they compete with one another to complete a round trip from Mather to the dam and back in under 70 minutes.

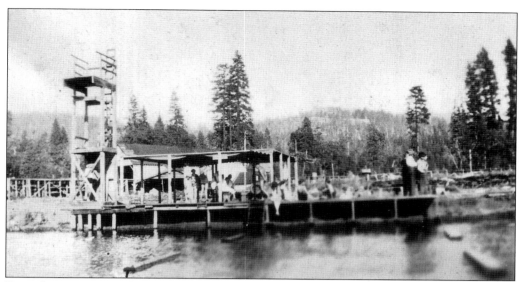

From the perspective of today's risk-averse society and the proliferation of rules and regulations designed to protect everyone from their own worst intentions, it is hard to believe that anyone would have allowed the construction of the diving tower shown in this picture. Most likely, it was extremely well made and would have remained standing to this day. (Courtesy of Garrison family collection.)

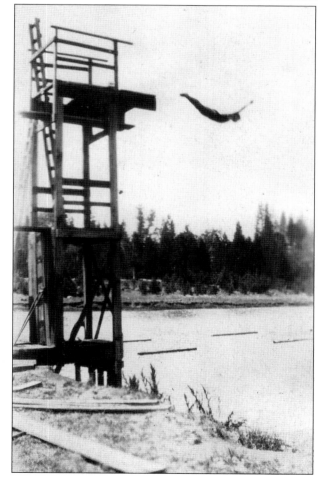

A beautiful swan dive executed by Joe Barnes is a sight to behold at Birch Lake. (Courtesy of Garrison family collection.)

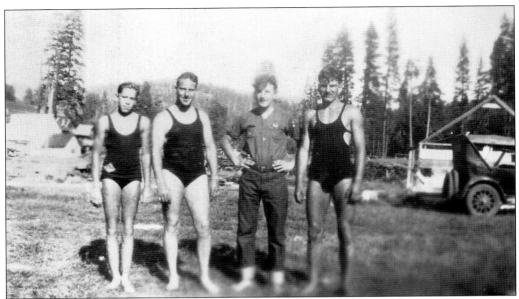

A group of friends poses on the lawn behind Birch Lake. The age of the automobile on the lawn, the still-standing mill complex in the background, and the style of the swimsuits places this photograph from the late 1920s to the early 1930s. Pictured from left to right are three unidentified men and Jack Garrison. Garrison would be hired in 1932 to drive a truck for the camp and would keep that job until 1951, when he left to own and operate the Evergreen Lodge. (Courtesy of Garrison family collection.)

In 1936, when construction resumed anew at the O'Shaughnessy Dam for the purpose of raising the height of the dam, Camp Mather again became a hub of activity. The railroad began operating again but was managed by the Sierra Railroad, and its terminus was Camp Mather. Guests had to be watchful for trucks hauling cement loads to the dam, and the serenity of the camp was shattered by the groan of diesel engines laboring up and down the camp roads. (Photograph by Horace B. Chaffee; courtesy of San Francisco PUC.)

Although the 4,520-foot elevation of Camp Mather is higher than that of Yosemite Valley (but not the surrounding region), the area does get large amounts of snow from time to time. During one particularly severe snowstorm in January 1932, the WPA work crews were stranded at Camp Mather. It took the relief train from Groveland 48 hours to get to the camp and rescue the men. This 1937 photograph shows the old cookhouse and surrounding grounds heavily blanketed with snow. (Photograph by George Fanning; courtesy of San Francisco PUC.)

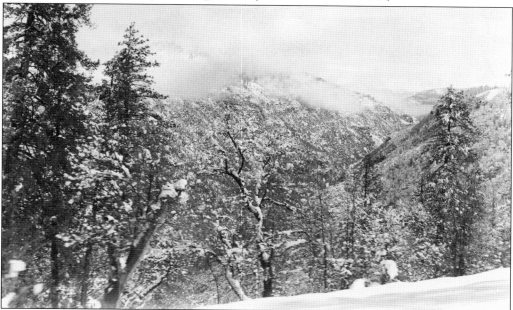

Even today, with more capable cars and all-weather roads, Camp Mather is not open in the winter; therefore, few visitors have experienced the wonder of the Tuolumne River gorge hillsides dusted in snow. This picture from 1937 was taken about a mile west of Camp Mather. (Photograph by Horace B. Chaffee; courtesy of San Francisco PUC.)

From time to time, it has been proposed that a winter-use plan be developed for the camp. Judging from this 1936 photograph of a frozen-over, snow-covered Birch Lake, the conditions appear to be right to form an ice rink. Winter access, staffing issues, and cold weather accommodations have been long-term impediments to seeing a winter-use program realized at Camp Mather. (Photograph by George Fanning; courtesy of San Francisco PUC.)

This snow scene at Camp Mather could easily be found anywhere in the Sierra during wintertime. The inviting drifts look perfect for a toboggan or cross-country skis. A full-time caretaker resides year-round at the camp to monitor conditions during the winter, make emergency repairs, and perform other seasonal duties required to maintain access to the camp and the O'Shaughnessy Dam. (Courtesy of San Francisco Recreation and Park Department.)

In March 1937, a group of hikers have assembled at a Tuolumne gorge viewpoint a short distance from Camp Mather. Although there was occasional heavy snowfall in the area (as seen on page 68 in a photograph taken three months earlier), the cold temperatures at the camp never lasted long enough to maintain the snowpack necessary to support a viable winter program. (Courtesy San Francisco PUC.)

A serene and contemplative scene in 1942 features an older couple, perhaps thinking about a war that is very far away. In spite of gas rationing, shortages of tires, and other hardships during that year, the camp was able to attract enough visitors to offer its regular summer season. Although suggestions were made in 1943 to close the camp, it remained open for the families of civilian and defense workers. Because of the labor shortage, it became necessary to hire below draft age male employees as camp assistants; a pilot program was implemented to hire girls to work in the dining hall. It was discontinued after one year. (Courtesy of San Francisco Recreation and Parks Department.)

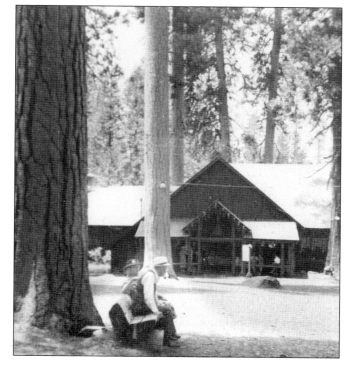

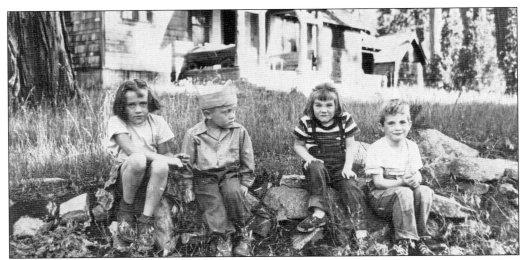

After the war years, Camp Mather experienced a boom in attendance, with reservations exceeding the accomodations available. City policy now required that all camp registrants must be residents of San Francisco. For this group of children in front of the camp manager's cabin (which would later be used exclusively by public utilities commissioners), the calamitous events of the past few years seem long ago as they enjoy a carefree summer. From left to right are Molly Center, Bobby Center, Laura Garrison, and Jeff Garrison. (Courtesy of Garrison family collection.)

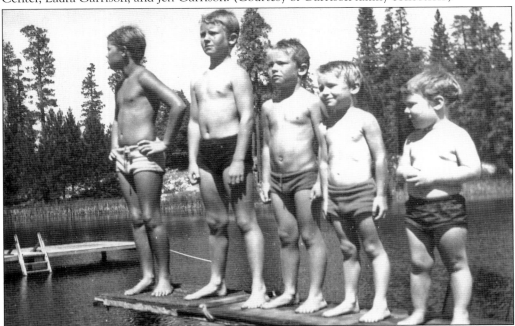

Since the early days of the late 1920s, the Hallinan family was well known in San Francisco. The father, Vincent, established himself as an attorney willing to battle for unpopular causes for social justice. His family initially attended Mather during the war years and later purchased a cabin in the CP&FG tract. Here five of the six Hallinan boys are arrayed on the diving board at Birch Lake. From left to right are Butch, Kayo, Tuffy, Dynamite, and Ringo. (Courtesy of Terence Hallinan family collection.)

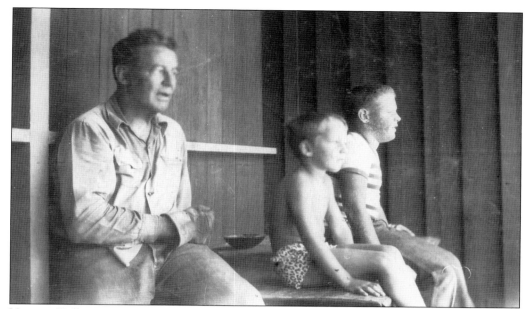

Vincent Hallinan reposes with two of his sons Danny (left) and Ringo (right). Well known as a spellbinding courtroom orator, Vinent was also a serious storyteller. At night, neighbors would secretly gather outside the Hallinan cabin to listen to him recite long passages from Greek myths, classic literature, and other sources that he had committed to memory. The extended family continues to spend the summer at their cabin near Camp Mather. (Courtesy of Garrison family collection.)

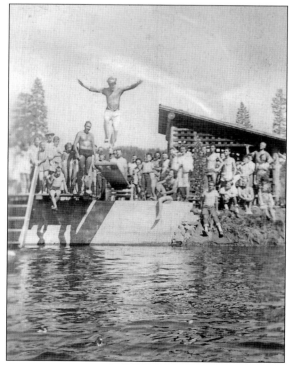

George Albrecht prepares to demonstrate his diving skills before an appreciative crowd at Birch Lake. He first came to Mather to work as a baggage handler. Later, when he was a schoolteacher, he continued his visits to the camp. A veteran of many U.S. Army/Air Force wartime missions, he died at a young age, but he left a sizable endowment to enable his friends to continue celebrating their Mather memories at an annual gathering in San Francisco. (Courtesy of George Albrecht collection.)

With the postwar baby boom well underway, attendance levels were on the increase, and it was getting more difficult to secure a reservation for the summer. Daily children's activities at Camp Mather were expanded to make the program more attractive to families. Here William Ergas, a camp employee, chats with the kids about the program arranged for them that afternoon. (Courtesy of San Francisco Recreation and Park Department.)

Here a late 1940s group of children gather in front of the dining hall awaiting news about the activities planned for them, including ping-pong at 6:30 p.m. and dancing in the lounge two hours later. Other scheduled events include an all-day saddle trip to Smith Peak on Friday and a breakfast ride on Saturday. The sports report for the Drips was not good; they were trounced 10-1 by the Drops in baseball action earlier in the week. (Courtesy of San Francisco Recreation and Park Department.)

A true cowboy in every sense of the word, Joe Barnes was born in Arizona in 1909. Since 1933, as an employee and later a manager of the Yosemite Park and Curry Company's horse corral operation, Barnes and his family have been as much a part of Camp Mather lore as Birch Lake. In 1959, Barnes was awarded the saddle and pack concession. His son Jay continues to operate the corral today. (Courtesy of Garrison family collection.)

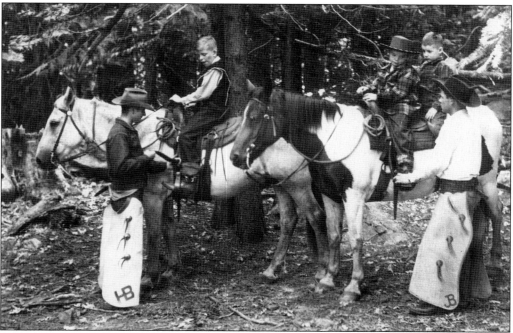

What young cowpoke has not secretly wanted a pair of chaps like those worn by wranglers from Joe Barnes's spread? Barnes's contributions to life at Camp Mather made each guest's stay unforgettable. He implemented the breakfast, moonlight, and children's rides. The corral also offered pack trips, rodeos, and private instruction. (Courtesy of San Francisco Recreation and Park Department.)

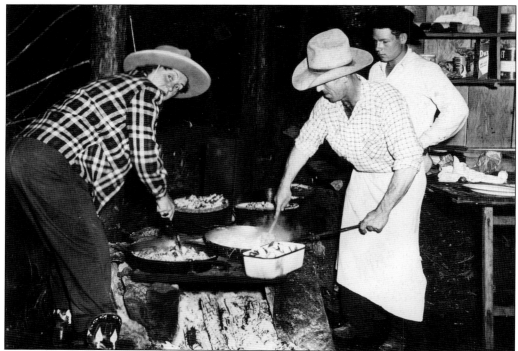

From left to right, Helen Joyner, Joe Barnes, and Jim Gulley rustle up some mouthwatering grub for famished Mather cowhands returning to camp after a hard day's ride in 1948. The smell of cooked food wafting across the camp is one of the many memories that have endeared the Barnes family to generations of Mather guests. (Courtesy of San Francisco Recreation and Park Department.)

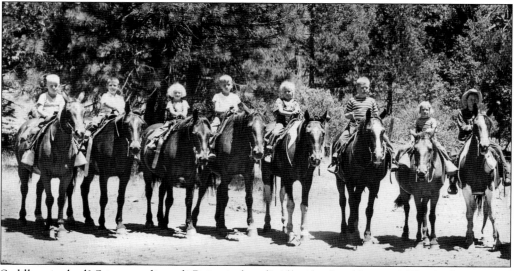

Saddles cinched? Stirrups adjusted? Reins in hand? All right, head 'em out! This lucky group of buckaroos is all set to take the grand tour of Mather while mounted on their trusty steeds. From left to right are Roger Hagaman, Jerry McCord, Diane Warden, Werner Schmidt, Nancy Coggins, Norman Coggins, Vicky Barnes, and Tommy Roper. (Courtesy of San Francisco Recreation and Park Department.)

The single-service line inside the dining hall caused an unpredictable but orderly queue to form at mealtimes. The line appears to have a mind of its own because it rarely repeats the same direction and formation from meal to meal. Patient parents pass the time with friends, while their children clamber about on the large rocks nearby. Events scheduled for July 14 include a car caravan to Hetch Hetchy Dam, afternoon splash time at the pool, a children's ping-pong tournament, and the staff talent show at 8:00 p.m. (Courtesy of San Francisco Recreation and Park Department.)

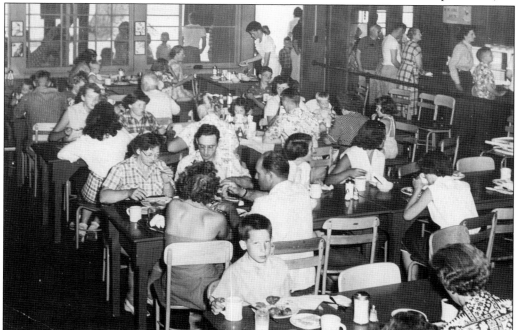

Real coffee mugs, glasses for milk, surplus schoolroom chairs, and wooden tables date this 1948 dining hall photograph. (Courtesy of San Francisco Recreation and Park Department.)

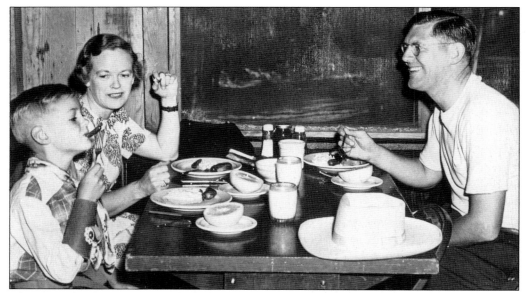

This same family scene from the late 1940s is still enacted today at Camp Mather. Few kids "smoke sausages" or wear cowboy gear to the dining hall, but the meal looks remarkably familiar. (Courtesy of San Francisco Recreation and Park Department.)

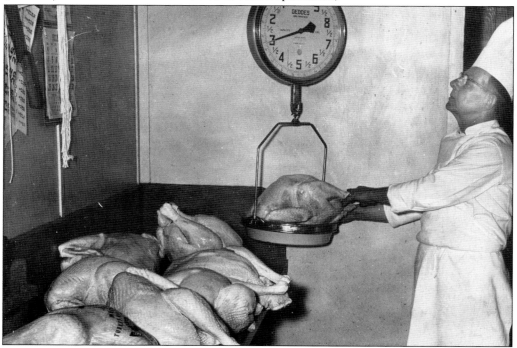

The meals at Camp Mather have always been great. The chefs are responsible for preparing three meals a day for upwards of 400 people. As most good cooks already know, turkey can be served in a variety of ways. Here the first iteration of turkey is weighed to ensure it meets the high culinary standards of the dining hall around 1948. (Courtesy of San Francisco Recreation and Park Department.)

The plunge, as it was sometimes known, seems sparsely populated today, and the absence of players on the tennis courts in the background seem to indicate that it is a hot day at Mather. A few saplings have been planted in the lawn area, but it will be years before they provide the shade so welcome to those who spend most of their day at Birch Lake. (Courtesy of San Francisco History Center, San Francisco Public Library.)

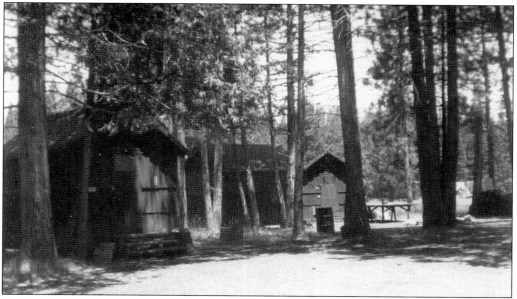

From the early days of the camp, employee housing has been less than luxurious. Nevertheless, employees have managed to create a warm and cozy environment, whatever their accommodations. Affectionately known as "Upper Shang" and "Lower Shang," names most likely derived from Shangri-La, these staff cabins were located across from what are now the hotel-style buildings out by the ball field. (Courtesy of Thomas McAteer.)

Tom McAteer proudly stands outside his quarters at "Shang," next to the skin of a large rattlesnake he has subdued in 1948. (Courtesy of Thomas McAteer.)

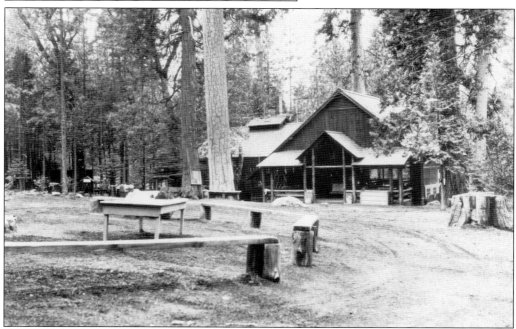

A view of the dining hall in the late 1940s is notable for the absence of any people in the picture. Local newspapers would often send photographers and reporters to Mather to take pictures for future stories promoting the upcoming season. Today these pictures are invaluable as they document the changes in the camp over its long history. (Courtesy of Richard Schadt.)

This unusual tree could be found on one of the little-used trails between Camp Mather and the Evergreen Lodge. A shelf fungus may have been responsible for the unusual ring growths found on the tree. Unfortunately, the tree is no longer standing, and postcards from the time are the only evidence of its existence.

When Josephine Randall was appointed to the San Francisco Playground Commission in the late 1930s, Camp Mather gained a strong ally who supported the development and growth of the camp for many years. A forceful advocate for recreation as a means to involve families in worthwhile activities, she was an early proponent for placement of recreation centers throughout the city. The Randall Museum is just one example of her leadership and vision. (Courtesy of Neil Fahy.)

In 1933, Bert Walker started a natural history program at the camp. By establishing a museum on the grounds, he was able to house collections of flora and fauna found in the area, as well as displaying Miwok artifacts discovered by lucky campers. His hikes around the camp and evening lectures were popular. His interpretive and historical programs added much to the knowledge and enjoyment of those fortunate enough to attend his presentations. He was later hired by Josephine Randall to develop a similar program for the San Francisco Recreation Department. (Courtesy of Neil Fahy.)

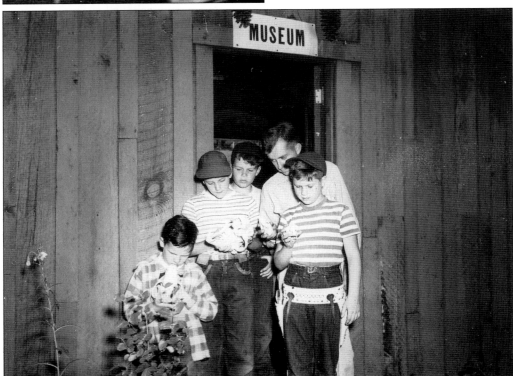

Camp naturalist Neil Fahy and a group of attentive campers compare and identify the different skulls he has brought out in front of the camp's museum. Educational programs were instructive and enjoyable for everyone. (Courtesy of Neil Fahy.)

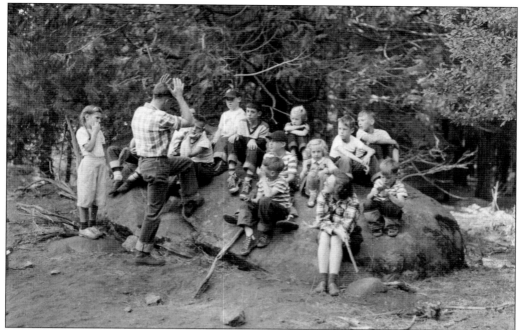

Children are naturally curious about the world around them. Here Neil Fahy explains the function of deer antlers to his attentive Mather rangers. He was first inspired to do the naturalist program by Bert Walker, and Neil served as a guide and naturalist for a number of years in the mid- to late 1940s. (Courtesy of Neil Fahy.)

Here Neil instructs a small group in the Miwok technique of using rock pestles and grinding rocks to render acorns into meal that can later be boiled to leach out the bitterness. He would often salt the area with obsidian fragments that would later be "discovered" by the children. (Courtesy of Neil Fahy.)

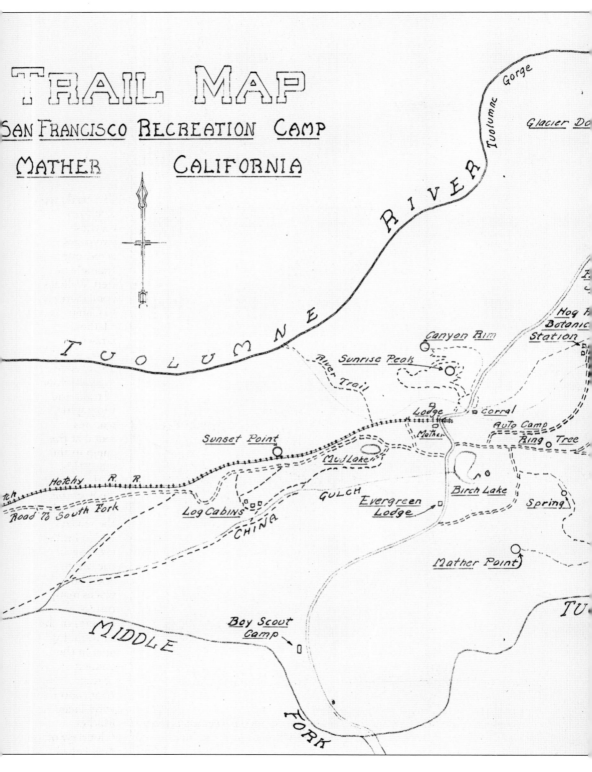

TRAIL MAP

SAN FRANCISCO RECREATION CAMP

MATHER CALIFORNIA

Tuolumne Gorge

Glacier Do

RIVER

TUOLUMNE

Hog P
Botanic
Station

Canyon Rim

Sunrise Peak

River Trail

Lodge Corral

Auto Camp

Mather Ring Tree

Sunset Point

Mud Lake

Hetchy R. R.

GULCH Birch Lake Spring

tch

Road To South Fork Log Cabins Evergreen
Lodge

CHINA

Mather Point

MIDDLE

Boy Scout
Camp

Tu

FORK

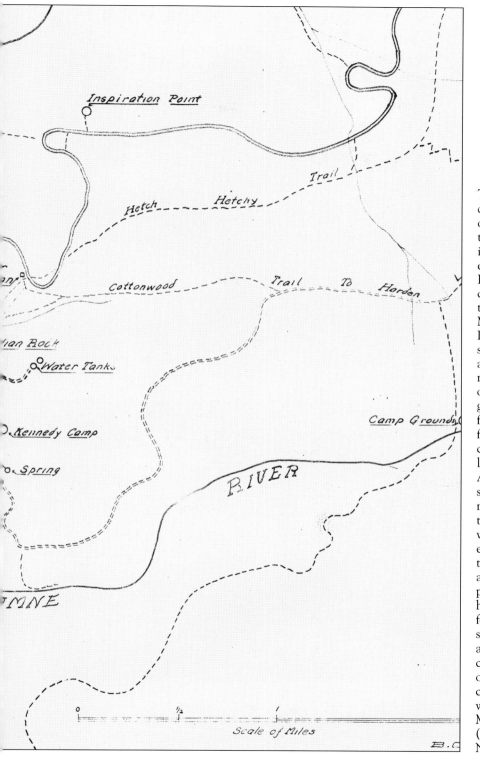

Inspiration Point

Trail

Hetch Hetchy

Cottonwood Trail To Harden

ian Rock

Water Tank

Kennedy Camp

Spring

RIVER

Camp Grounds

MNE

0 ½ 1

Scale of Miles

B. C

The trail map displayed on these two pages is just one example of Bert Walker's contributions to Camp Mather. Drawn to scale, it is an accurate representation of trails and geographic features found at the camp in the late 1930s. A thorough study of the map rewards the reader with a bird's-eye view of the camp and also places many historical features of the surrounding area in the context of their connection with Camp Mather. (Courtesy of Neil Fahy.)

The lighter side of the camp staff is presented in this photograph of the "Mather Glee Club." Here they serenade the assembled guests with a selection of jukebox hits from 1948 and camp favorites gathered across the years. (Courtesy of George Albrecht collection.)

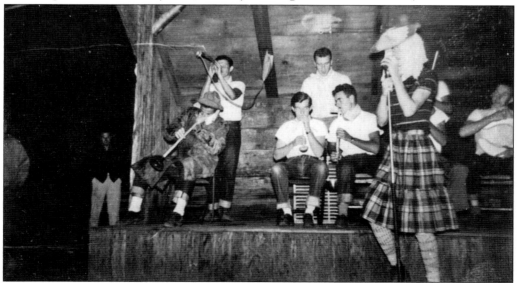

The staff talent show has always been a highly anticipated camp event. Often marked by elaborately staged hoaxes played upon the guests, the presentations provided a humorous interlude and a fitting end to the day's activities. During the Depression, the "hat was passed" in order to compensate for the low wages paid to staff at the time. Here in 1948, the camp band pounds out a hot tune, much to the audience's delight. (Courtesy of Neil Fahy.)

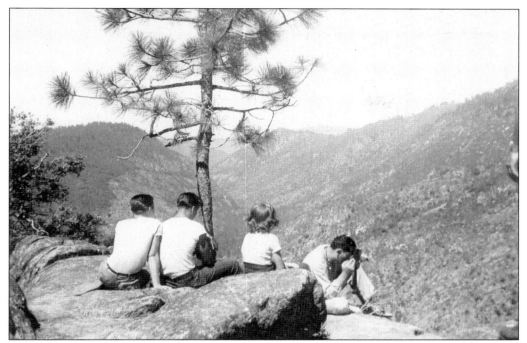

A 15-minute walk from camp brings the hiker to Inspiration Point on the canyon's rim. The view of the Tuolumne gorge is truly remarkable. An entire week's sojourn at the camp could be spent just following the trails and visiting the sites illustrated on Bert Walker's map, all easily reached from the main campground. The quiet solitude experienced during these strolls is a peaceful antidote to the bustle that normally characterizes Birch Lake. (Courtesy of Neil Fahy.)

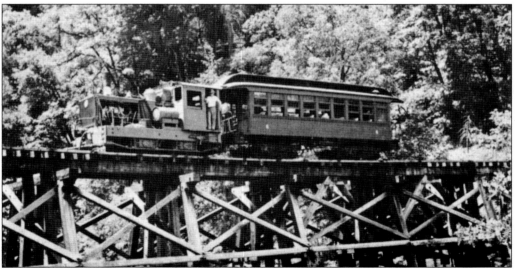

Rail fans discovered the Hetch Hetchy Railroad just before the tracks were removed and the right-of-way converted to vehicle use. This lucky group was able to charter a passenger train—Locomotive No. 1171 and Coach No.6—to make the 64-mile round-trip from Groveland to Mather. Sadly, this was the first (and last time) many of the passengers were able to experience the beauty of this railway; the tracks would be torn up a year later. (Courtesy of *Western Railroader* magazine.)

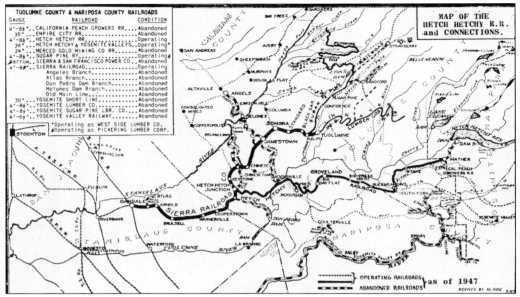

By 1947, most of short-line railways that plied the richly forested hills of Tuolumne and Mariposa Counties were gone and their rail lines long abandoned. The original route of the Hetch Hetchy Railroad is shown on this map along with its connections to other lines. The Sierra Railroad was an important link in the complex transportation system that maintained a steady supply of men and materials for the dam project. A barely discernible line next to Mather illustrates the tiny area served by the California Peach and Fig Growers Railroad.

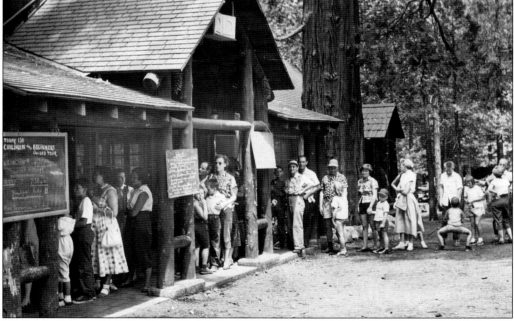

The huge trees around the dining hall provide endless hours of diversion for the squirrels in camp and kept the children occupied while the dinner line slowly made its way inside. White socks worn by the women and the sport shirts on the men speak to dress styles of the late 1940s.

Having a municipal camp has certain advantages. The close network of city employees is like an extended family, and everybody seems to know everybody else. Families of city workers were regulars at Camp Mather, and when surplus pieces of food service equipment became available, they often found a home at the dining hall. The source of this beautiful stove is unknown, but the soup kettles were courtesy of the hospital, and the warming tables came via Candlestick Park. (Courtesy of Dan Dempsey family.)

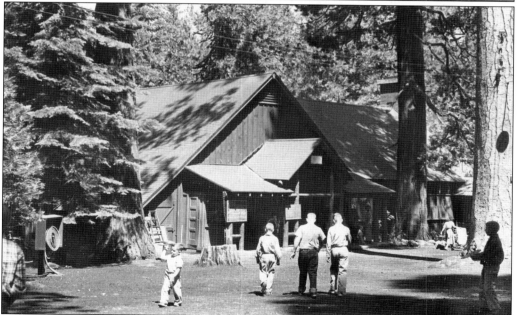

Nestled among the trees, the dining hall has been the subject of numerous photographs. With the exception of the modifications to the food service operation, it has remained fundamentally unchanged for decades until the open-air deck and seating area was added in the early 1990s. Always a warm and welcoming beacon, it still serves as the focal point for many of the social activities of camp life. (Courtesy of Dan Dempsey family.)

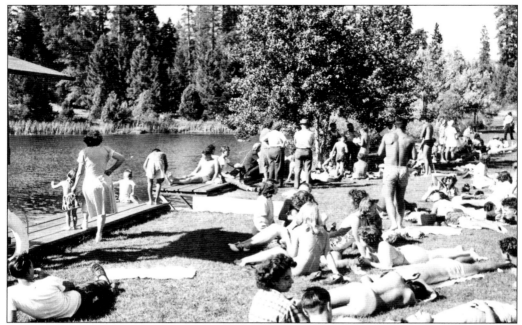

Meanwhile, on the other side of camp, the lawn area of Birch Lake is brimming with activity. A long, narrow dock fronts the lake, and a notch between two sections allows for easy access to the water. Folks are crowded together around the few large shade trees that provide relief from the hot afternoon sun. (Courtesy of Garrison family collection.)

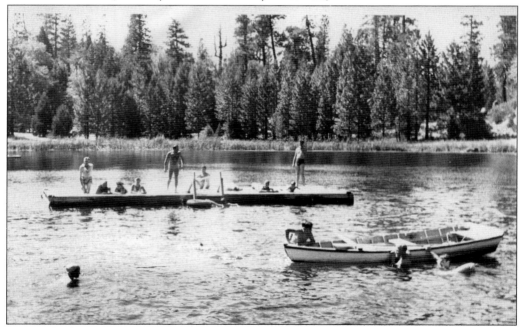

Out on the lake, a group of swimmers amuse themselves with a small wooden boat. Sunbathers are soaking up the sun's rays before plunging again into the refreshing waters of the lake—a cycle that is repeated endlessly during the summer. (Courtesy of Dan Dempsey family.)

Two of Camp Mather's lifeguards, Walt Henry (left) and Dick Minderman, mug for the camera in this 1960s photograph taken at Birch Lake. Minderman started as a staff assistant, later became a lifeguard, and was appointed camp manager in 1972. A metal and woodshop teacher at Woodrow Wilson High School, he was a popular figure at the camp. (Courtesy of Ellen McAllister.)

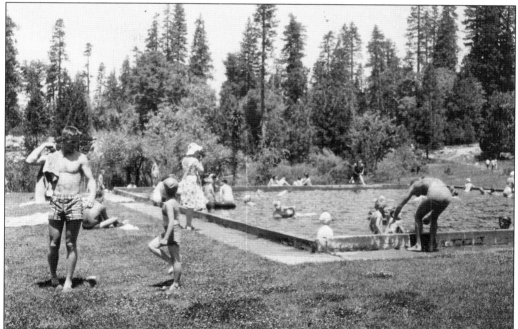

For those less secure in their abilities to handle the swimming demands of Birch Lake, the enclosed swimming pool has always offered an inviting place to splash, romp, and just cool off. The cement plunge was cold but was not easy for young children to use. (Courtesy of Garrison family collection.)

The lagoon behind the main lake offered a pleasant alternative to the chlorine, brisk temperature, and high energy of the swimming pool. Its shallow depth and warm water have always made it attractive for toddlers. The grassy area is also a nice spot for parents to relax while keeping a watchful eye on the kids. (Courtesy of Dan Dempsey family.)

Periodically, it was necessary to completely drain the lake in order to clear out aquatic debris, perform routine maintenance, and recontour the lake bottom. Once the water has been pumped out, all that remains is to bring in a tractor to remove silt and other unwanted material and then spread clean sand to form a new bottom for the following season. (Courtesy of Dan Dempsey family.)

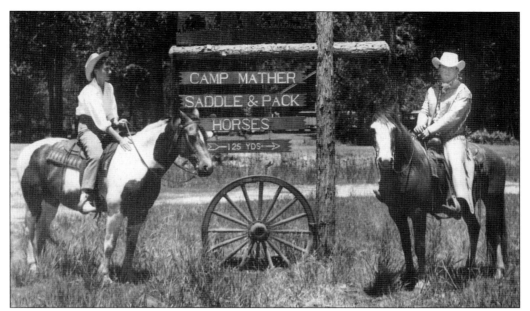

Doris Perry, camp hostess, and Joe Barnes, manager of the saddle and pack concession, are pictured in this "stock" shot that probably ran in one of the local San Francisco dailies. Since the early 1930s, the camp hostess has played an integral role in the smooth running of the camp. Duties included scheduling activities, answering questions, leading group tours, and otherwise acting as a quasi concierge. (Courtesy of Doris Perry Fox.)

After a temporary location next to the camp office, a permanent store and post office opened in 1947. The post office was originally part of Mather Station until it was moved to Evergreen Lodge from 1934 to 1945. The general store has met the needs of many families over the years by providing food, beverages, sundries, toys, ice cream, and a few items one would not expect to find so far from home. It was a place to grab a quick snack between meals or buy a bag of ice. In many ways, it was the neighborhood corner store brought to Camp Mather. (Courtesy of San Francisco Recreation and Park Department.)

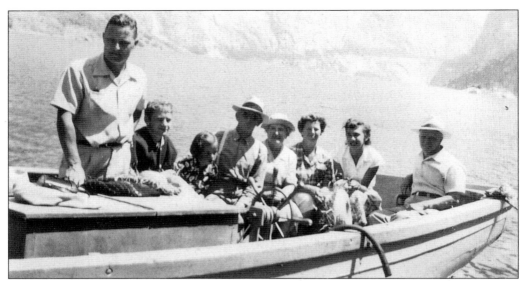

As a hostess, Doris Perry (second from right in this 1952 picture) enjoyed working at Camp Mather to ensure that the guests had a pleasant and uneventful stay. On one occasion, she was fortunate to be able to tour the O'Shaugnessy Reservoir in one of boats reserved for the exclusive use of PUC employees. Working at Mather, on occasion, has some extra special rewards. (Courtesy of Doris Perry Fox.)

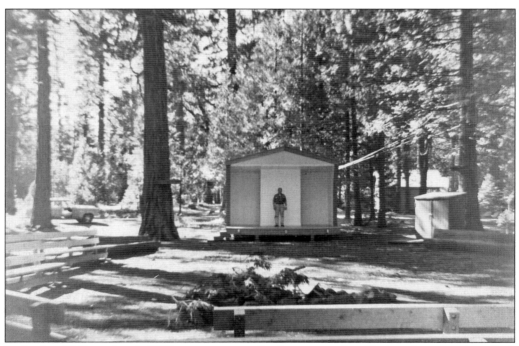

In the late 1940s and early 1950s, a proper stage for the guest and staff talent shows was installed, and the quality of presentations improved accordingly. Benches were later added to the area to allow for more comfortable viewing of the evening's fare. (Courtesy of Dan Dempsey family.)

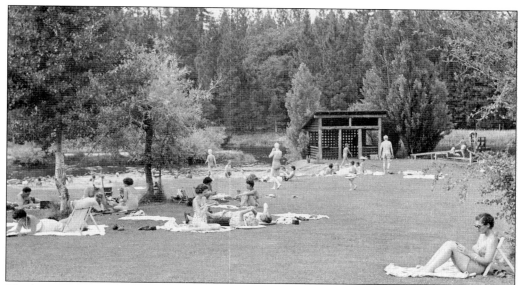

The large expanse of well-manicured lawn at the lake invites Mather guests to linger. Picnickers enjoy the shade of the larger trees; divers make use of the newly installed board; lifeguards store their equipment in the wooden building between the lake and the shallow area; and readers find a spot well away from the crowd to work on a tan and finish that book they have been meaning to read all year. (Courtesy of Dan Dempsey family.)

The general store was the last hope to buy all the things forgotten at home. It also was a source of inexpensive trinkets, candy, and ice cream for free-spending children learning how to manage their money. Here Martin Murphy and Maybelle Lewin stand behind the counter, ready to serve the next customer. (Courtesy of Garrison family collection.)

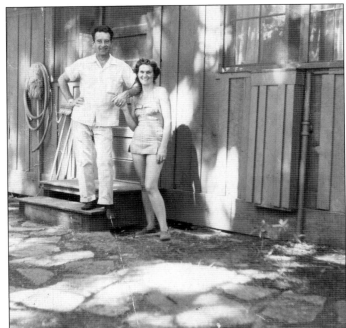

Camp manager Dan Dempsey and his wife, Martha, were a familiar presence at Mather for many summers. Dan managed Camp Mather from 1955 to 1971. On the first day of camp, he would always announce to the new guests that he could be found behind the "green door" of the manager's cabin. (Courtesy of Dan Dempsey family.)

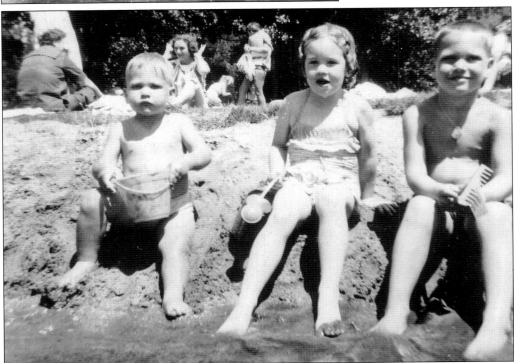

Squeezing sand through toes and filling up buckets is a comforting way to spend time at the lake when one is young. From left to right, Ed Barisone, Jan Dempsey, and John Barisone take a break from their busy schedules to pose for this 1950s photograph. Jan would later become undersheriff for the City of San Francisco. (Courtesy of Shirley Barisone.)

Sam and Maybelle Lewin chat it up with some friends in the late 1940s. Sam worked in the accounting office at the camp and was also camp manager for the second half of the 1954 season. They were a well-liked couple who could be found at both the Evergreen Lodge and the Mather store. (Courtesy of Garrison family collection.)

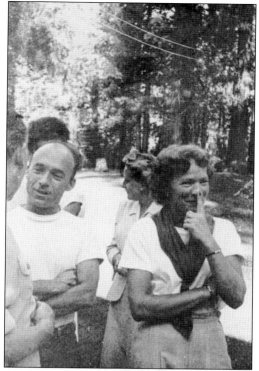

Long before recycling, composting, and hauling trash to distant landfills became the norm, refuse at Camp Mather was handled the easy way—it was dumped and burned on-site. This brought no end of nutritional delight to the ever-resourceful bears that looked upon the camp's approach to refuse management as manna from heaven. The arrival of the bears provided nightly entertainment for the children who would safely observe the bears as they foraged. (Courtesy of Dan Dempsey family.)

William Merchant was a yeoman architect who previously worked with Bernard Maybeck on the Palace of Fine Arts, as well as the Treasure Island World's Fair. He received numerous contracts to design facilities that would expand the capacity of the camp. His most notable undertaking was a master plan for the camp that, if adopted and implemented in the mid-1950s, would have seen the placement of a 100-room lodge at the north end of Birch Lake and additional cabins/employee housing for use during the winter months. (Courtesy of Environmental Design Archives, University of California.)

In the early 1950s, private cars were not allowed beyond the check-in area at the office. Arriving guests were met by staff who then unloaded the visitor's car, transferred their belongings to carts like the one shown in this picture, and finally transported the personal belongings to the appropriate cabin. These carts also did double duty for parents when it became necessary to take the children home when they came down with the measles. Pictured from left to right, Tommy, Eddie, and John Barisone enjoy a free cart ride from their father, John, prior to returning home to San Francisco. (Courtesy of Shirley Barisone.)

The creative recreation staff was always trying new and wacky ideas to get guests to outdo themselves while participating in camp activities. Here are four contestants in "Crazy Hat Night." Pictured from left to right are Janet Bailey, Jim Bailey, Ellen Bufalini, and Alice Bailey. No record is available indicating if anyone in this group won. (Courtesy of Ellen McAllister.)

Adding porches to Mather's cabins was a big plus and greatly appreciated by all campers. Even with the doors and windows open, the cabins were often hot and stuffy. The porch was a nice place to read a book, enjoy a beverage, hang up a wet towel, or watch the squirrels gamboling amongst the trees. (Courtesy of San Francisco Recreation and Park Department.)

Over the life of the camp, the issue of favoritism in gaining admission to the camp has created such a furor that at least two grand juries have investigated the issue, as has the city itself. The conventional belief was that city employees received preferential treatment, a charge that was never supported during the course of any official investigation. Nonetheless, a reservation system and proof of residency requirements were instituted to address such concerns. Here an early group of would-be Mather campers lines up in the early 1960s outside McLaren Lodge in Golden Gate Parks in hopes of securing one of the coveted spots for the upcoming season. (Courtesy of San Francisco Public Library.)

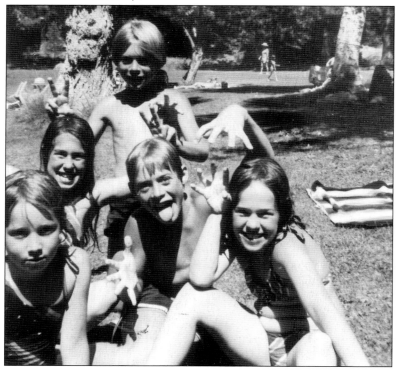

A group of campers demonstrate their youthful exuberance while posing for this picture near Birch Lake. Pictured from left to right are (first row) Nicole Mrakava and Julie McAllister; (second row) Laureen McAllister and Kenny England; (third row) Kevin England. Kevin would later become part of the camp's work crew, while Julie would work in the kitchen and eventually be hired as a lifeguard. (Courtesy of Ellen McAllister.)

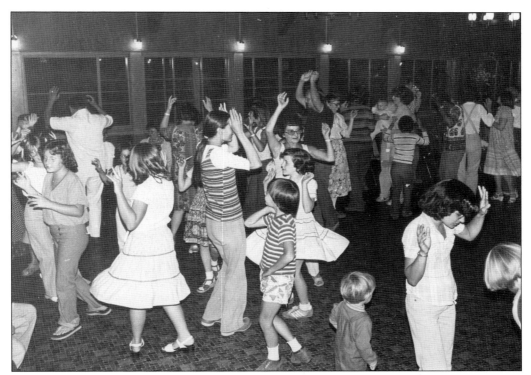

From time immemorial, the "Hokey-Pokey" has remained what it is all about. The dining hall floor in 1961 is packed with enthusiastic dancers of all ages and abilities showing off their best moves. (Courtesy of Ellen McAllister.)

In the early 1960s, Shirley Barisone (left) and Martha Dempsey relax on the dock by Birch Lake. The trees in the background are full grown, and the lake has finally taken on the appearance of the summer camp envisioned by its early supporters and advocates. (Courtesy of Shirley Barisone.)

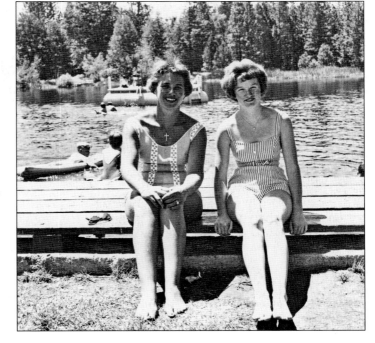

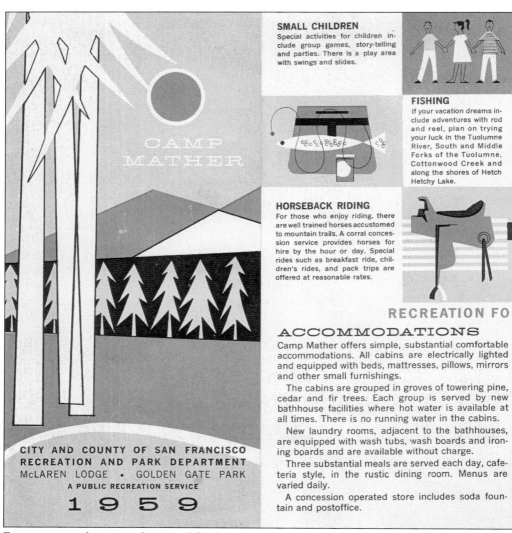

SMALL CHILDREN

Special activities for children include group games, story-telling and parties. There is a play area with swings and slides.

FISHING

If your vacation dreams include adventures with rod and reel, plan on trying your luck in the Tuolumne River, South and Middle Forks of the Tuolumne, Cottonwood Creek and along the shores of Hetch Hetchy Lake.

HORSEBACK RIDING

For those who enjoy riding, there are well trained horses accustomed to mountain trails. A corral concession service provides horses for hire by the hour or day. Special rides such as breakfast ride, children's rides, and pack trips are offered at reasonable rates.

CAMP MATHER

CITY AND COUNTY OF SAN FRANCISCO
RECREATION AND PARK DEPARTMENT
McLAREN LODGE • GOLDEN GATE PARK
A PUBLIC RECREATION SERVICE
1959

RECREATION FOI

ACCOMMODATIONS

Camp Mather offers simple, substantial comfortable accommodations. All cabins are electrically lighted and equipped with beds, mattresses, pillows, mirrors and other small furnishings.

The cabins are grouped in groves of towering pine, cedar and fir trees. Each group is served by new bathhouse facilities where hot water is available at all times. There is no running water in the cabins.

New laundry rooms, adjacent to the bathhouses, are equipped with wash tubs, wash boards and ironing boards and are available without charge.

Three substantial meals are served each day, cafeteria style, in the rustic dining room. Menus are varied daily.

A concession operated store includes soda fountain and postoffice.

Fancy new graphics are a feature of the Camp Mather brochure produced in 1959. The activities and amenities remain largely unchanged from those first advertised and promoted in the brochures from the early 1930s, but the design certainly has a peppy look. (Courtesy of Neil Fahy.)

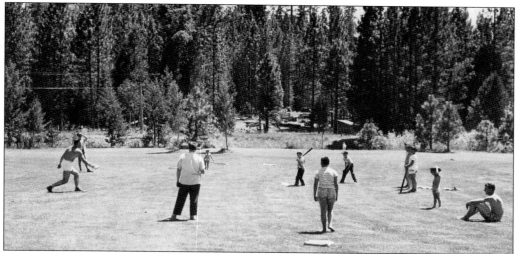

A pick-up game of baseball is underway on the ball field adjacent to the employee housing. About 1949, the ball field was moved from Macarthy Field to Lou Taylor Field. It has evolved into a multiuse site that supports soccer games, baseball, and other field sports, including guests-versus-staff contests. The openness of the area makes it a perfect spot for stargazing. (Courtesy of Dan Dempsey family.)

For those who first began to visit Camp Mather in the late 1940s, the allure of summer in the Sierra remains strong, even through the teenage years. Here members of a 1959 work crew gather in the parking lot near the general store before heading over to the lake to socialize. Pictured from left to right are Tony Patch, Don Ante, Frank Cafaretta, and Bob Cafaretta. (Courtesy of Ellen McAllister.)

Few homes in San Francisco have the space to accommodate a ping-pong table. Summers at Mather afford the opportunity both for children to learn how to play and for experienced players to hone their skills. Shadows, wind, and dings in the table invariably affect the outcome of the game, leveling the playing field and often rendering ability irrelevant. (Courtesy of Shirley Barisone.)

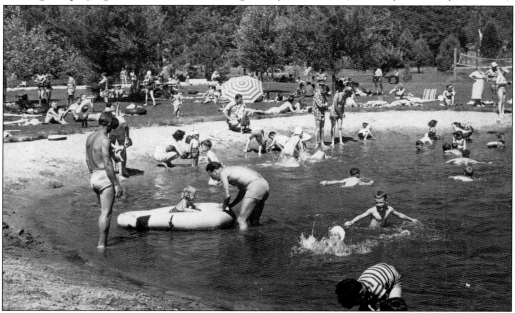

Another glorious day in the sun at Birch Lake is pictured here. The shallow wading area has been enlarged, but it is still safe for younger swimmers. A boy with an inner tube awaits his chance to take it out on the lake. The volleyball court is quiet, but that could change at any moment. Carefree moments such as these were hard to come by in the tumultuous 1960s, making the time spent at Camp Mather a welcome respite from more serious matters. (Courtesy of Ellen McAllister.)

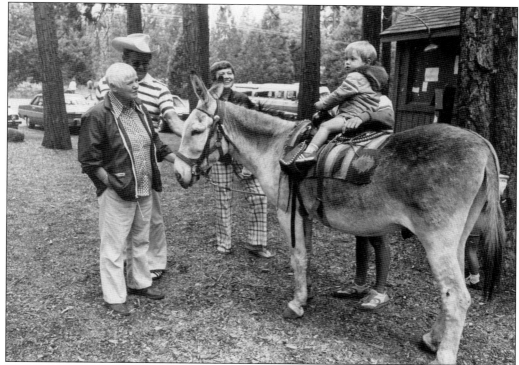

This first time rider is not quite sure what to make of being on the back of a donkey. Under the watchful eye of Jay Barnes (in the cowboy hat), she and other members of her group will have an uneventful but exciting ride around the camp perimeter. (Courtesy of Ellen McAllister.)

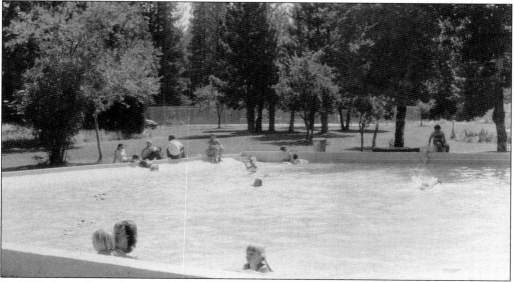

By 1973, the pool was the equivalent of any modern swimming facility, although it was unheated and at times could be quite cold. By moving it away from the center of the lawn area, it freed up more space for people to gather and spread out. A cabana was added later to give a little shade. (Courtesy of Groveland Ranger District, Stanislaus National Forest.)

CAMP MATHER

Camp Mather, a unit in the extensive recreation and park system operated by the City and County of San Francisco, is a family camp, elevation 4520 feet, on the rim of the Tuolumne River gorge above the great Hetch Hetchy valley, approximately one hundred eighty miles from San Francisco.

The area surrounding Camp Mather embraces some of the most beautiful scenery in the world.

THINGS TO DO

SWIMMING

Excellent swimming facilities are available in Birch Lake and in a pool, both located in the camp. A life guard is on duty every day. A spacious lawn area for sunbathing adjoins the lake and pool.

HORSESHOE COURTS

Pitching horseshoes is one of the most popular camp activities. Equipment is available to guests without charge.

OTHER GAMES

Facilities are available for tennis, badminton, ping pong, volleyball and softball. Frequent tournaments are scheduled for both adults and children.

RECREATION PROGRAM

Experienced recreation personnel lead group games, organize tournaments, arrange dances, and serve many other recreational interests.

A page from a 1959 camp brochure follows the pattern of previous booklets and touts the benefits of a stay at the camp. The photographs common in the 1930s versions are gone, and the 1950s graphics add a much needed visual punch. (Courtesy of Neil Fahy.)

Good pals Jimmy Dempsey and Ed Barisone stand on the dock at Birch Lake. A separation between sections of wooden platform provides easy step-down access to the lake. (Courtesy of Shirley Barisone.)

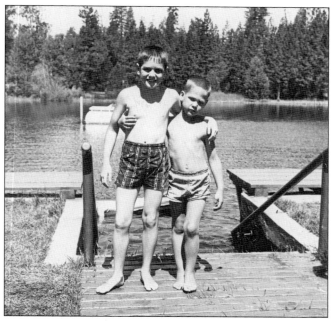

Larger cabins can now be found on the Birch Lake side of camp. These are more spacious and allow for larger groups to share space. Built with rooms back-to-back, they add a new feel to the lodging experience at Mather. (Courtesy of Shirley Barisone.)

IN THE HIGH SIERRA

Camp Mather, a unit in the extensive recreation
park system operated by the City and County of
Francisco, is a family camp, elevation 4520 feet,
the rim of the Tuolumne River gorge above the
at Hetch Hetchy valley, approximately one hundred
hty miles from San Francisco.

The area surrounding Camp Mather embraces some
the most beautiful scenery in the world.

THINGS TO DO

SWIMMING Excellent swimming facili-
ties are available in Birch Lake and in a
pool, both located in the camp. A life
guard is on duty every day. A spacious
lawn area for sunbathing adjoins the
lake and pool.

RSESHOE COURTS Pitching
seshoes is one of the most popu-
camp activities. Equipment is
ailable to guests without charge.

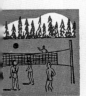

OTHER GAMES Facilities are available
for tennis, badminton, ping pong, volley-
ball and softball. Bring your tennis and
badminton racquets, ping pong paddles,
balls and birds.

RECREATION PROGRAM Experi-
enced recreation personnel lead
group games, organize tournaments,
arrange dances, and serve many
other recreational interests.

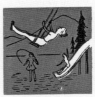

SMALL CHILDREN Special activities
for children include group games,
story-telling and parties. There is a
play area with swings and slides.

CAMP FIRE PROGRAMS Campfire
programs, featuring community sing-
ing and impromptu acts performed
by guests, are presented each week.
The camp recreation leaders organ-
ize these programs

HIKING Easy walks and long or shor
hikes along the numerous mountain
trails bring the vacationer to the
beauty of the primitive mountain
country. Sunrise Peak and Inspira
tion Point are favorite spots fo
breath-taking panoramic views o
Hetch Hetchy valley, O'Shaughnessy Dam and the deep
Tuolumne River gorge.

The last of the graphically significant, four-page, colorful, foldout brochures made its appearance
in 1963. In subsequent years, smaller-sized brochures would be produced, and the breadth of the
descriptive information about the camp significantly reduced. The original of this brochure is in
vivid red and white, a contrast to the more subtle pamphlets that would follow. The information

FISHING If your vacation dreams include adventures with rod and reel, plan on trying your luck in the Tuolumne River, South and Middle Forks of the Tuolumne, Cottonwood Creek and along the shores of Hetch Hetchy Lake.

AUTOMOBILE TRIPS Camp Mather is a perfect center for sightseeing. The famous Hetch Hetchy reservoir and O'Shaughnessy Dam can be reached in a twenty minute drive. Yosemite Valley and Cherry Valley Dam, thirty miles away, are about an hour's ride. A one day trip over some of the most scenic roads in the Sierras takes one to May Lake, Teneya Lake, Tuolumne Meadows and Tioga Pass.

HORSEBACK RIDING For those who enjoy riding there are well trained horses accustomed to mountain trails. A corral concession service provides horses for hire by the hour or day. Special rides such as breakfast ride, children's rides, and pack trips are offered at reasonable rates.

ACCOMMODATIONS

Camp Mather offers simple, substantial comfortable accommodations. All cabins are electrically lighted and equipped with beds, mattresses, pillows, mirrors and other small furnishings.

The cabins are grouped in groves of towering pine, cedar and fir trees. Each group is served by new bathhouse facilities where hot water is available at all time. There is no running water in the cabins.

New laundry rooms, adjacent to the bathhouses, a equipped with wash tubs, wash boards and ironir boards and are available without charge. Electric iro are not provided.

Three substantial meals are served each day, caf teria style, in the rustic dining room. Menus are vari daily.

A concession operated store includes soda fountain, sundr and post office. Automatic washing machine service is av able at a nominal charge.

WHAT TO BRING WITH YOU

Informality prevails at all times, in all activitie Slacks, sport shirts, wash dresses are very popul dress-up attire.

Informal sport clothes are recommended and p haps more rugged outdoor clothing, swimming su and cameras will add enjoyment to the vacatione stay at camp.

A flashlight is advisable; and if you bring an elect iron or hot plate, include in your packing list an e tension cord, a double socket and plug. Should y desire to lock your cabin, bring your own padlock a key.

No special food preparation is made for very sm children, so parents are advised to bring a hot pl for the baby's formulas and special foods.

Guests Must Provide Their Own Blankets and Line

Extra blankets are advisable in the event of c evenings.

presented in this brochure continues to emphasize the range of programs, activities, and services available at camp, while suggesting other nearby places of interest that are easily reached by car. (Courtesy of Neil Fahy.)

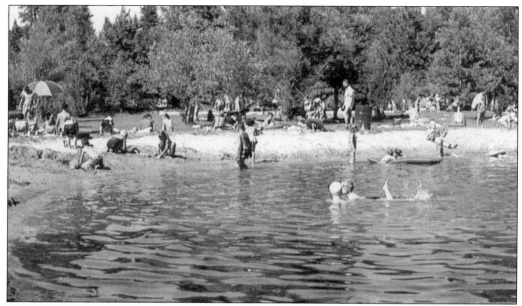

This postcard view of Birch Lake is unusual as the photographer is immersed in the wading area in order to get the perspective of looking back on the lawn. The trees are fairly large now, and the lawn area is beginning to resemble what one sees at camp today.

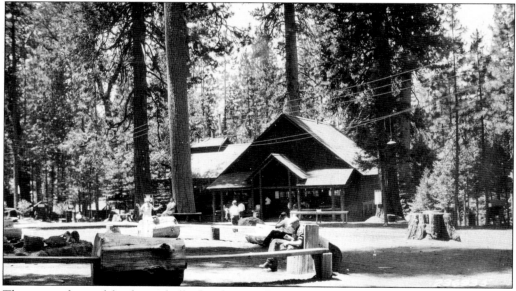

The area in front of the dining hall is bustling on this fine summer day in 1961. The log and plank circle still serves as the site for the weekly campfire. The comfortable chairs hewn out of logs provide a nice spot to plan out the day's activities. Seating is also available around the trunks of some of the large trees. An outdoor addition constructed to the right of the building will create extra seating and become a vibrant social spot during mealtimes.

Seven

REFLECTIONS
OF THE PAST

Since 1924, Camp Mather has occupied a special place in the hearts of San Francisco families. Multiple generations of the same family have made a trip to the camp an essential part of their summer. The icons of the camp—the dining hall, Birch Lake, and the Barnes's horse corral—remain constants in a rapidly changing world. Life at Mather harkens back to simpler times and strengthens family ties. Children are free to explore the camp and experience a level of freedom and independence impossible to find in their own urban neighborhoods. Spending an unstructured day with your friends riding bikes everywhere is liberating, yet in this village, that feeling is created anew each summer week. And kids are never far removed from the watchful eye of a parent willing to intercede should the situation warrant. For one week of the year, everything is taken care of for families. The city seems far behind, and the dictum of renewal espoused by those early progressives of the last century seems more applicable now than before. The words from the 1926 Margaret Maryland Camp brochure say it best: "Your sole duty is to amuse yourself. Bring your blankets and good disposition—all else is provided."

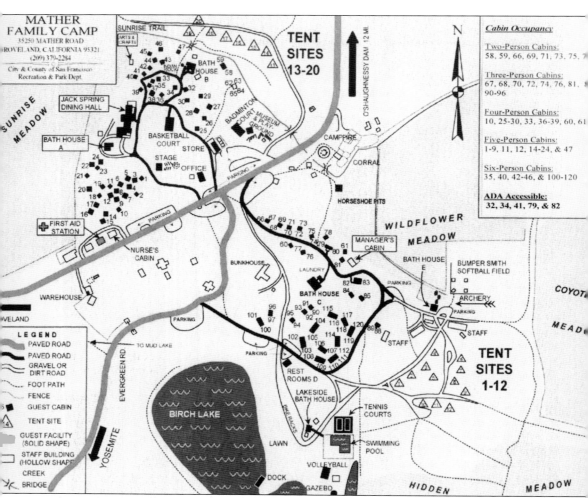

This useful map of Camp Mather is an ideal way to become acquainted with the physical features of the grounds. The unnamed meadows of the Hog Ranch days are now identified, the clusters of cabins are easily located, and the recreational features described in the previous chapters are now seen in relation to the overall layout of the campground. (Courtesy of San Francisco Recreation and Park Department.)

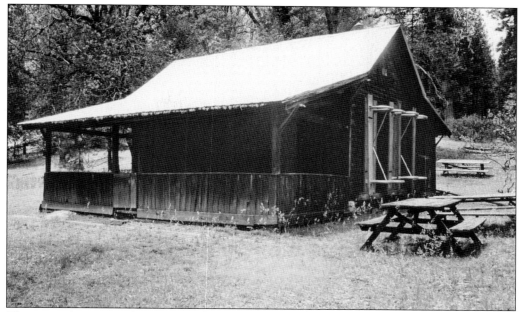

The original Hog Ranch cabin remains standing on the same spot where it was built in 1856. It is the oldest building owned by the City of San Francisco. A long hike past employee housing leads to the cabin trail. One can also discover the crumbled foundation of a building thought to have once housed U.S. Army personnel when troops patrolled Yosemite National Park to keep sheep and cattle from grazing in the lush meadows. (Photograph by Neil Fahy.)

This building, located near Birch Lake, was the main office when the sawmill was in operation. It is the oldest structure on the campgrounds that is left from the construction days of the 1920s and 1930s.

When the city purchased the Hetch Hetchy lodge from the Yosemite National Park Company, the deal also included about 25 wooden cabins. The structures, identifiable by their casement-style windows, are still in use today. (Courtesy of Richard Schadt.)

The building that was once the center of a thriving work camp has now been relegated to an obscure part of the campground over by the corporation yard. It is still used as a warehouse and is certainly capable of being recycled for a use more consistent with its historic connection to Camp Mather. (Courtesy of Richard Schadt.)

Many visitors erroneously believe that the water supply for the camp comes from Hetch Hetchy Valley. The cost of pumping water up the steep canyon six miles to Mather, however, would be prohibitive. The actual source is Cottonwood Creek, which originates in Yosemite National Park and is used by permission of the National Park Service. A combination of 20,000-gallon wooden and metal tanks, plus an on-site chlorination system, ensures a safe and healthy water supply.

In 2003, the city purchased two prefabricated cabins at a cost of $18,000 each to replace a pair that were beyond salvaging. With up-to-date electrical systems and screen doors, they offer a contemporary housing alternative when compared to the older, more rustic cabins. Though small, they have the advantage of being stand-alone units that are quiet and have heat.

Some campers sleep in tents away from the hustle and bustle of the main camp center. This affordable alternative makes it possible for many families who prefer a simpler camping style to enjoy a weeklong stay at Mather.

Old Priest Grade claims another victim! Even with today's modern automobiles, the shorter, faster route up old Priest Grade can prove taxing to a cooling system, especially after crossing the San Joaquin Valley in 100-degree heat. Fortunately, road service and a flatbed tow truck enable a stranded family to reach Mather without missing a single day of fun.

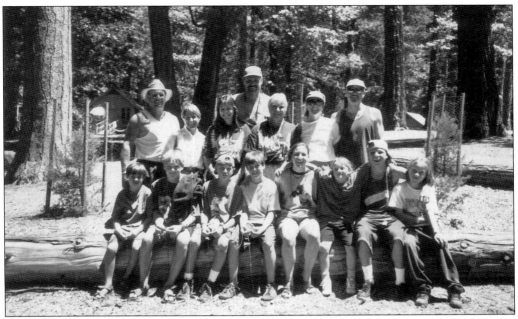

The multigenerational appeal of Camp Mather is well exemplified in this photograph of Shirley Barisone (second row, third from right), her three sons, their wives, and her grandchildren. Shirley was a guiding figure in establishing the first Friends of Camp Mather organization and actively works to improve conditions at Mather and generate political support for the continuance of the family camp. She has been attending Mather for over 70 years. (Courtesy of Shirley Barisone.)

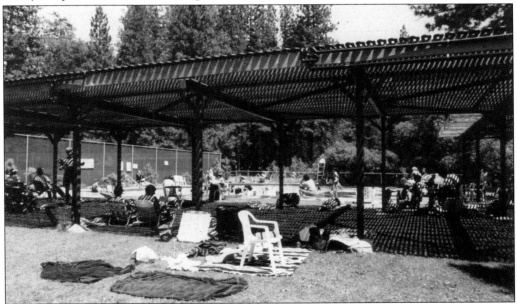

Today's version of the swimming pool is located near the tennis courts and sports a roof that provides welcome shade on hot days. Lifeguards and fencing ensure the safety of all swimmers. At the pool, lessons are offered free of charge, and the Birch Lake swim test is held for children under the age of 16. (Courtesy of Shirley Barisone.)

Bikes, bikes, and more bikes! More than one child has learned to ride a two-wheeler while staying at Mather. The flat terrain and the absence of cars make it a bike friendly place, affording children freedoms not found in most San Francisco neighborhoods. Many children remark that what they like best about camp is riding their bike. A scattered clump of bicycles awaits their owners at Birch Lake.

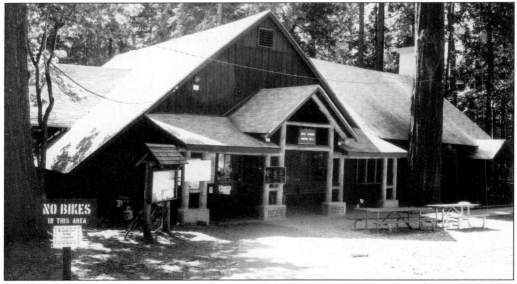

The dining hall has been renamed in honor of Jack Spring, a longtime general manager of the San Francisco Recreation and Park Department. The outside patio addition has expanded the seating capacity of the facility. Many guests prefer to order a sack lunch and spend the day at the lake or on an outing. Dinner is a celebratory occasion as families and friends gather for a leisurely meal.

For several decades, the sound of this bell has announced that breakfast is ready or has summoned folks from afar to dinner. Fashioned in the early 1940s by a city ironworker who was a guest, it is an aural icon of the Mather experience.

Michael Cunnane has been a familiar presence in the dining hall for many years. As a member of the kitchen staff, he worked summers peeling vegetables after graduating from the University of California, Berkeley. He later became interested in food preparation for large groups and went on to be certified in hotel and restaurant management. He became a senior cook in 1975 and was named chef in 1979. Though served cafeteria style, his high-quality meals are more reminiscent of home cooking. The Hobart mixer to his left was made in 1936 and is the second oldest example of that machine still in operation.

Claudia Reinhart, the current camp manager, and Maria Velazquez, who is working at the camp for the summer, take a break from their busy schedules to pose for this picture. Budget cuts and rising costs are making it increasingly difficult to provide the level of service that veteran campers have become accustomed to. With the help of the Friends of Camp Mather, a nonprofit volunteer organization that assists the San Francisco Recreation and Park Department, the camp strives to keep Mather affordable and offer the customary amenities. (Courtesy of Claudia Reinhart.)

High school graduates are eligible to work in the kitchen and serve as staff assistants. Here Terry Cunnane and several unidentified young workers are finishing up the dishes in the dining hall. Bussing trays, serving food, singing "Happy Birthday," and cleaning up the inevitable spilled tray are just some examples of the valuable services they render to guests at camp. The young people who compirse the camp staff that work in the kitchen and elsewhere do so much to make a visitor's week at Camp Mather carefree and relaxing.

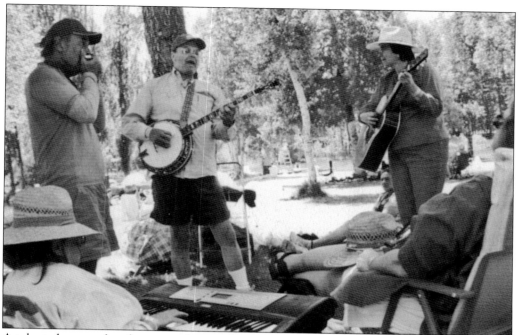

A talented group of performers gathers in the shade at Birch Lake to provide a musical backdrop for the day. The players have coordinated their reservations to ensure that all members will be present during the same week. The lawn area resounds with lively tunes that entertain onlookers and invite others to join in with their instruments. Pictured from left to right are Steve Rubenstein, George Martin, Pauline Scholten, and Birdie Yusba (on keyboard). (Courtesy of Lynn Ludlow.)

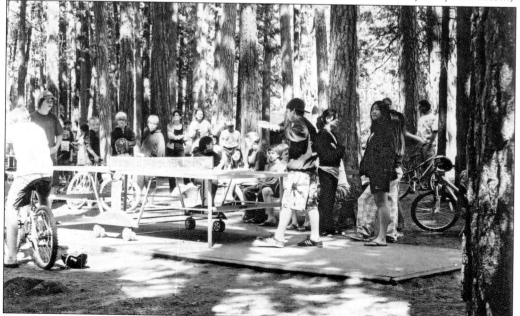

The ping-pong tables are in constant use. Tournaments are held each week for all age groups. Winners receive a certificate that is presented during the guest talent show.

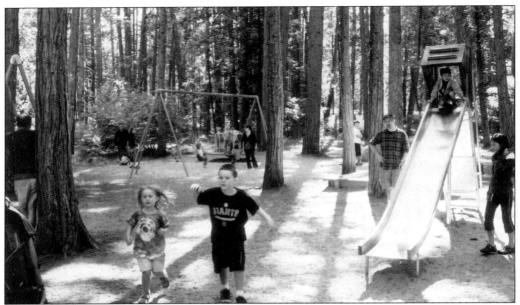

The children's playground behind the badminton courts and next to the camp museum is a throwback to when play structures were fun and exciting. Amongst the tall trees, children can swing, slide, and ride the merry-go-round to their heart's content.

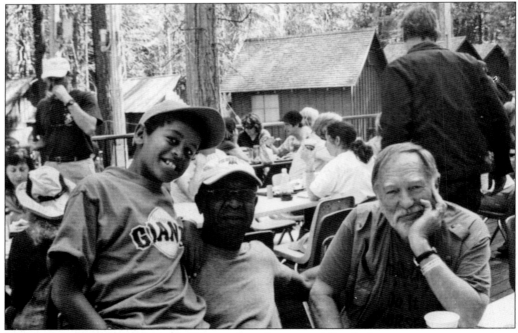

The outdoor deck off the dining hall is a perfect place to socialize during warm summer evenings. Guests linger over their meals, especially at dinnertime when the highlights of the day are shared among family and friends. Shown here from left to right, Cameron Grigsby pauses with his father, Roy, and grandfater Lynn Ludlow prior to running off for some last minute fun before another day at Camp Mather comes to a close. (Courtesy of Lynn Ludlow.)

One of the original bathhouses for the camp is now the arts and crafts building. Located down the hill from the dining hall near the creek that separates cabins from tent sites, it continues to serve the needs of the camp.

In 1936, the Catholic archbishop of San Francisco requested and was granted permission to hold Mass at camp. Meat was not allowed in Catholic households on Friday and thus began the camp tradition of serving fish for that day's evening meal. Later a priest would come up from Sonora on Saturday and hear confessions in the building shown in this photograph. The original confessional has been moved to a location behind the maintenance staff cabin near the tennis courts. (Courtesy of Richard Schadt.)

The view of the road cut at the summit has remained unchanged since this photograph was taken in 1924. The paved road and four-percent grade make it an ideal excursion for cyclists wishing to make the 13-mile trip from the camp to the dam and back. Depending on the direction, one can be treated to an exhilarating downhill ride to the dam that is punctuated by the sound of running water, alternating warm and cool zones, and the sound of tires humming on the pavement. Alternatively, after the long grind up the hill, the sight of the summit means a successful climb out of the valley and a descent to camp is imminent, with only a short stop at the Yosemite Ranger Station to interrupt the journey home. (Courtesy of San Francisco Public Utilities Commission.)

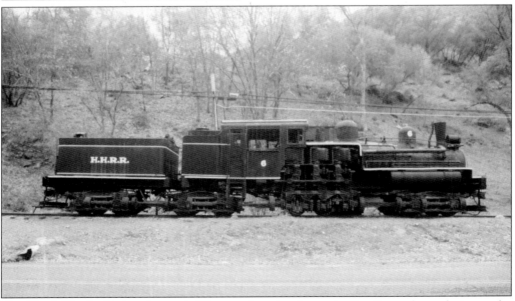

The Hetch Hetchy Railroad was a brilliant engineering feat and a fiscally prudent solution to the problem of how to bring crews and materials through the mountains to a remote construction site. This 100-ton Shay locomotive was the largest of the engines used in the project and was employed to haul cement up the Priest Grade portion of the railroad. It now resides along the road in El Portal, just outside Yosemite National Park. (Courtesy of Richard Schadt.)

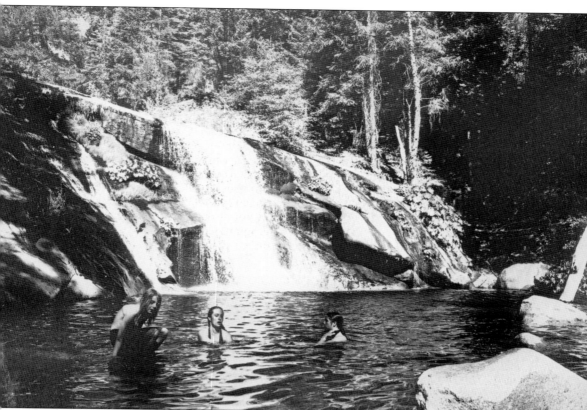

Carlon Falls is an ideal destination for a day hike. Located at the Carlon Falls Day-Use Area off Evergreen Road, the gentle contours of the trail make it an easy trek for hikers of all ages. Those willing to ascend the hillside to Carlon Falls are well rewarded for their efforts. Walking up the canyon, the trail passes water-filled depressions and multiple branches of a cascading stream that lead to a gorgeous waterfall and a deep pool. These swimmers have returned from the small cave behind the waterfall and are feeling invigorated after being pummeled by the falling waters. From left to right are Zane Buck, Erin Harris, and Madeleine Buck.

As the trail from Carlon Falls returns to the parking lot, it passes the remaining edges of the old Carl Inn resort swimming pool. In the same area can be found evidence of the building foundations once used by employees of the inn and later by road crews of the California Department of Transportation. A little beyond these historic features, the South Fork of the Tuolumne River broadens out and flows over shallow riffles. The easy hike down the banks of the river provides a welcome, foot-cooling shortcut back to the entrance of the day-use area.

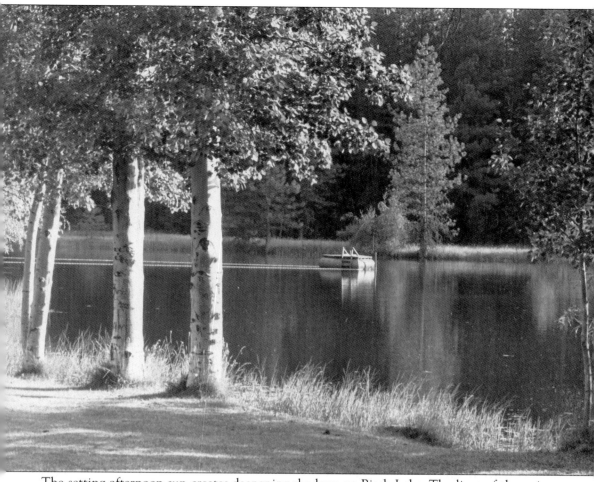

The setting afternoon sun creates deepening shadows on Birch Lake. The lines of the swim lanes stretch invitingly to the floating platform. Nary a ripple is to be found on the lake's surface. Another day at the lake comes to an end. (Courtesy of Richard Schadt.)

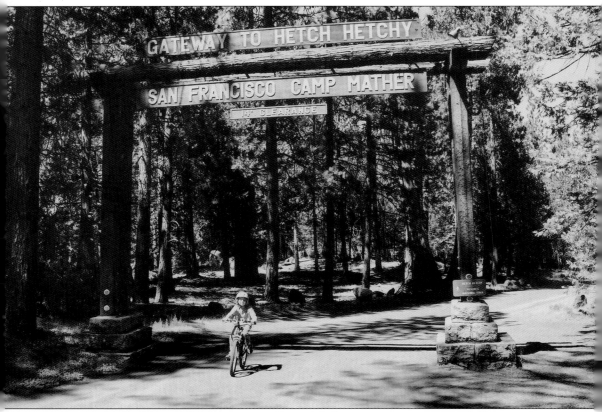

As is true with all good things, a stay at Camp Mather must come to an end. Here a solitary bicyclist, Zane Buck, passes beneath the entrance portal for one more quick spin before packing it up and heading home. Another year must pass before he will be able to return to San Francisco's Jewel of the Sierra.

BIBLIOGRAPHY

Albright, Horace M., and Marian Albright Schenck. *Creating the National Park Service*. Norman, OK: University of Oklahoma Press, 1999.

Giacomazzi, Sharon. *Trails and Tails of the Yosemite and the Central Sierra*. Mendocino, CA: Bored Feet Press, 2001.

Jones, Holway R. *John Muir and the Sierra Club—the Battle for Yosemite*. San Francisco, CA: Sierra Club, 1965.

Paden, Irene, and Margaret Schlichtman. *The Big Oak Flat Road to Yosemite*. Yosemite, CA: Yosemite Natural History Association, 1959.

Righter, Robert W. *The Battle of Hetch Hetchy*. Oxford, NY: Oxford University Press, 2005.

Shankland, Robert, *Steve Mather of the National Parks*, New York, Alfred A. Knopf, 1970.

Taylor, Ray W. *Hetch Hetchy—The Story of San Francisco's Struggle to Provide A Water Supply For Her Future Needs*. San Francisco, CA: Ricardo J. Orozco, 1926.

Wurm, Ted. *Hetch Hetchy and Its Dam Railroad*. Berkeley, CA: Howell-North Books, 1973.

ACROSS AMERICA, PEOPLE ARE DISCOVERING SOMETHING WONDERFUL. *THEIR HERITAGE.*

Arcadia Publishing is the leading local history publisher in the United States. With more than 4,000 titles in print and hundreds of new titles released every year, Arcadia has extensive specialized experience chronicling the history of communities and celebrating America's hidden stories, bringing to life the people, places, and events from the past. To discover the history of other communities across the nation, please visit:

www.arcadiapublishing.com

Customized search tools allow you to find regional history books about the town where you grew up, the cities where your friends and family live, the town where your parents met, or even that retirement spot you've been dreaming about.